Silver Lake

CHRONICLES

Silver Lake
CHRONICLES
Exploring an Urban Oasis in Los Angeles

MICHAEL LOCKE
WITH VINCENT BROOK

THE
History
PRESS

Published by The History Press
Charleston, SC 29403
www.historypress.net

Front cover, top left: Colonel William Selig with a baby elephant, circa 1913. *Courtesy of the Academy of Motion Pictures Arts and Sciences. Front cover, top right*: Mach Sennett (carrying his hat) visiting Marceline Day on the set of *The Gay Deceiver* (1926). *Front cover, bottom right*: George Watson, dean of Los Angeles Photographers, during his stint as second staff photographer for the *Los Angeles Times*, 1919. *Courtesy of the Watson Family Photo Archive. Front cover, bottom left*: Mack Sennett's Bathing Beauties, 1919.
Back cover, left: The Silver Lake Reservoir. *Photo by Michael Locke. Back cover, right*: Antonio Moreno, cover of *Motion Picture* magazine, February 1920.

First published 2014

ISBN 9781540208217

Library of Congress Cataloging-in-Publication Data

Locke, Michael (Michael J.)
A brief history of Silver Lake : an urban oasis in Los Angeles / Michael Locke with
Vincent Brook.
pages cm
Includes bibliographical references and index.
ISBN 978-1-60949-958-7 (paperback)
1. Silver Lake (Los Angeles, Calif.)--History. 2. Silver Lake (Los Angeles, Calif.)--
Biography. 3. Los Angeles (Calif.)--History. 4. Los Angeles (Calif.)--Biography. I. Brook,
Vincent, 1946- II. Title.
F869.L86S555 2014
979.4'94--dc23
2014036894

Dedicated to Hynda Rudd and the memory of Ada Brownell

CONTENTS

Acknowledgements

When I signed a contract with The History Press in 2012 for my book on Silver Lake, little did I know what challenges lay ahead. Although I had written hundreds of newspaper articles, this subject's complexity was well beyond my previous experience. Knowing that I would have to narrow my focus, I first thought I would deal solely with the aspect about which I knew the most: the history of mid-century architecture. But as I began researching, I soon discovered that no comprehensive study of Silver Lake's early history had yet been completed, nor had anyone undertaken the task of archiving documents relating to its past. Thus, I would be starting pretty much from scratch.

In 2003, the recently formed Silver Lake Neighborhood Council established a history collective committee, which has done an amazing job of compiling (and continuing to compile) video and oral histories of Silver Lake residents. The records are housed at the University of Southern California (USC) in the Bob Herzog Memorial Archives, named in honor of a prominent, recently deceased chair of the collective. As valuable as all this work has been, I believed a broader contextual history, such as I envisioned, might also enhance their efforts.

In November 2013, I arranged a public meeting at the Silver Lake Branch Library with the dual purpose of opening a dialogue on my book project and providing impetus for a local historical society. The history collective supported the first idea, and Michael Masterson, co-chair of the collective, was especially helpful in recommending me to The History Press. The sixty or so persons who attended the meeting were asked to fill out a questionnaire about their specific

interests and expertise, and although the historical society never materialized, the questionnaires proved invaluable in laying the groundwork for my book.

I had already been poring over books and articles on the history of the general area and scanning old manuscripts and photographs. The library meeting gave me further tips on people to interview—those who had lived in the area for longer periods of time, knew of others who had or just had a memory or story to share. Another benefit of the library meeting was my learning of the work of Ada Brownell, recently deceased, who had written articles in the 1990s for the *Silver Lake Residents Association Newsletter* and had been collecting newspaper clippings and photographs for her own prospective book project. I found Ada's files at the home of Sherman McClellan and Joy Tinsley, who generously allowed me to scan the documents.

Beginning to zero in on persons of interest from the past, I began a correspondence with Carol Hagedorn, grandniece of Mary Bonadiman, who had had the foresight to keep a rich account (in handwritten notes and photographs) of her family's pioneering days in Silver Lake. Joe and Joann Lightfoot, current owners of the Bonadiman family home, offered additional insight and information on the historical who's who of the community.

The library meeting also introduced me to Bud Overn, a Clifford Street School classmate of Charles Hathaway, of Hathaway Hill Mansion fame. Charles's son Frank Garbutt Hathaway later met me at the Los Angeles Athletic Club, sharing his memories of living at the mansion and allowing me to scan historical photos. Bud also offered photos relating to another prominent local family, the Watsons, to whom another of my chapters is devoted. Realtor Karen Lower was instrumental in arranging a tour of the Watson family home. And my friend Nettie Carr, historian of next-door Atwater Village, expanded the Watson connection through her contact with Daniel and Antoinette Watson, keepers of the Watson Family Photo Archive, whose generosity in sharing this prized collection proved a major coup.

Through my membership with the Los Angeles City Historical Society (LACHS), I had previously met Hynda Rudd, Los Angeles's first city archivist, who had written her master's thesis on Jews of the intermountain West and, in the process, had learned about Herman Silver, to whom she jokingly referred as her "patron saint." Hynda's research was invaluable in helping me tell Silver's story. And besides her overall encouragement, she and LACHS president Todd Gaydowski introduced me to Michael Holland, the current Los Angeles city archivist, who gave me access to the city's archives.

My affiliation with the LACHS bore further fruit in a meeting with historian Helene Demeestere, whose research on architect Armand Monaco

inspired me to include his story in the book. Through the website Ancestry. com, I was able to connect with some of Armand's living descendants and others close to the family. My first contact was with Leslie Ruelas, whose grandmother lived with the Monaco family during a time of difficult transition. Leslie has been extremely useful throughout the project in helping unravel the mysteries of the Monaco family.

Yvonne Ng, librarian at the Arcadia Public Library, generously allowed me free access to the library's archives as they related to Hugo Reid, a key figure in early Los Angeles and Silver Lake history. Ng also introduced me to Ronald C. Woolsey, author of *Migrants West: Toward the Southern California Frontier*, who was kind enough to give me a free copy of his excellent book. I was most fortunate to meet Clara Togneri shortly before she died and later had the pleasure of meeting other members of her family, including Greg and Marie Togneri. Besides the information I gleaned about the Togneris' contribution to Silver Lake, a major bonus for all of us was the later designation, through our collaboration, of their family estate, Villa Palombo-Togneri, as a Los Angeles historical landmark.

Good friend Genelle LeVin, president of the Silver Lake Improvement Association, introduced me to many VIPs in the neighborhood and shared valuable information about Roscoe Arbuckle, the great silent-era comic. Designer/restaurateur Dana Hollister was very gracious in opening her home, the Canfield-Moreno Estate (also known as the Crestmont or the Paramour), on many occasions, which allowed me the opportunity to photograph the interiors, as well as to hear her fascinating personal story. Dr. Kenneth Williams and his wife, Sally, invited me into their home to tell their family saga, as did Dr. Thomas Berne and his wife, Cynthia, to talk about Thomas's father, Dr. C.J. Berne. This information about prominent physicians who lived in the area formed the crux of my chapter on Pill Hill.

I'm grateful to John Chadbourne and Halla Picado of Equity Title Company for their exceptional research in verifying addresses from the past. Jerry Roberts, commissioning editor for The History Press, has been a bulwark of support throughout. And I'm beholden to owner-director Jesse Rogg of the newly reopened Silver Lake branch of Mack Sennett studios, built by Sennett in the 1910s for his film star and lover Mabel Normand. Besides resuscitating the historic studio—which is once again operational and just celebrated its one-year anniversary—Jesse gave me the carte blanche treatment.

A special thanks to *Los Angeles* magazine associate editor Chris Nichols, who has been one of my most enthusiastic supporters and has provided several of the photos that grace these pages. And last but not least, I am

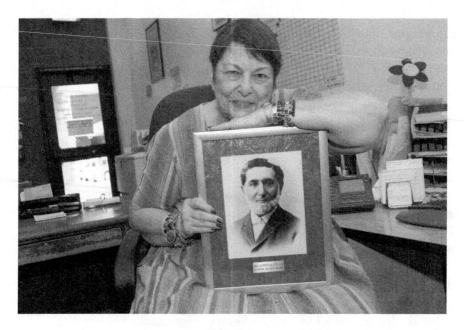

Los Angeles's first archivist, Hynda Rudd, holds a portrait of her "patron saint" Herman Silver. *Photo by Michael Locke.*

deeply indebted to Vincent Brook, media studies professor, friend and fellow local activist, who came aboard late in the project and whose editorial skills and historical expertise (along with the research of his wife, Karen) have greatly enhanced the finished product.

Over the course of my research and writing, many of the people I met along the way have passed away or moved out of the area. I'm grateful I was able to interview them when I did—before their stories were lost for all time. My personal motto from the start has been Lest We Forget, though, I also wondered, "How many stories have I left out? Whom have I overlooked?" Of course, I never intended this small book to be all-inclusive. I saw it as a corollary to the ongoing work of the history collective and the impetus to further discovery. Nettie Carr and the Friends of Atwater Village (FAV), for example, while working on the publication of their book on the history of Atwater Village, met descendants of the pioneering W.C.B. Richardson family, who donated a treasure-trove of documents, diaries and photos to FAV. I can only hope that my book similarly moves someone to share new information about old Silver Lake.

INTRODUCTION

The name for the community to which we now refer as Silver Lake did not exist until sometime after 1907, the year the Silver Lake and Ivanhoe Reservoirs went into service. From possibly as early as the 1830s, the area was part of a larger swath of open land known as Edendale, stretching south and east of Griffith Park and the Los Angeles River. This area also included what are today Los Feliz, Franklin Hills, East Hollywood, Echo Park and Elysian Valley.[1]

Other than brief encounters by Spanish explorers Juan Cabrillo, in 1542, and Sebastián Vizcaíno, in 1602, no substantial contact had existed between Europeans and the Tongva (the native people of the region) until August 2, 1769. That's when Don Gaspar de Portolà, captain of dragoons in the España regiment, arrived in what is now the Los Angeles basin, with an expeditionary party. The Tongva had gradually replaced the previous indigenous group, the Chumash, between 500 BCE and 500 CE, with the Chumash moving farther north along the coast into what are now Ventura, Santa Barbara and San Luis Obispo Counties.[2]

Among the Tongva people's fifty to one hundred small settlements (of fifty to two hundred people each) was one near what is now Los Angeles's central Plaza, which they called Yang-na (or Yaanga). There are no records of any native village in Silver Lake specifically, although the Tongva did hold ceremonies (and continue to do so) in what is now Elysian Park. Another of their settlements, known as Mochohuenga, was situated at present-day Ferndell, near the entrance of Griffith Park.[3]

El Pueblo de Nuestra Senora la Reina de Los Angeles del Rio Porciúncula (Los Angeles for short) was founded on November 4, 1781.[4] In 1782, Spanish colonial governor Pedro Fages granted a 6,647-acre parcel in the later-named Edendale area to Jose Vicente Feliz. Feliz had traveled with Juan Bautista de Anza's expeditionary party through the region in 1774 and would be appointed one of the pueblo's first mayors. A portion of his Rancho Los Feliz would, of course, give its name to present-day Los Feliz. Other parts of future Edendale overlapped with adjoining ranchos and with Los Angeles proper. Even after it took on the name of Edendale, most of the area remained sparsely populated farmland until the real estate boom of the late 1800s.[5]

With the arrival of transcontinental rail connections, the discovery of oil, thriving agriculture and tourism industries and access to a reliable water supply, people began arriving in Los Angeles at a dizzying rate. Between 1870 and 1910, the population grew from a mere 5,000 to over 320,000. From 1920 to 1929, with the help of the burgeoning film and aerospace industries, it doubled from 577,000 to over 1.2 million.[6] Silver Lake benefited from, and contributed to, this enormous growth. One of the first signs was the construction of the Silver Lake and connected Ivanhoe Reservoirs, after which the Edendale designation gradually disappeared as new communities within its boundaries adopted the separate identities they carry today. A few references to the erstwhile name remain, such as in the Edendale Grill, a restaurant and bar located at the restored Fire Station Number Fifty-six in Silver Lake, and the Edendale branches of the public library and post office in Echo Park.

Like the larger city of Los Angeles of which it is a part, Silver Lake was formed from a combination of modern and romantic facets. The city's population spurt, which began in the late 1800s, demonstrates this to a remarkable degree. One of the main impetuses for the surge of people into the larger region was the novel *Ramona*, written by Helen Hunt Jackson in 1884. An international bestseller, the book was intended by its author to draw attention to the plight of the California Indians. Local boosters, however, drew on Jackson's colorful portrayal of the Mexican ranchero period to create a usable past to lure mainly midwestern Americans to the area—and with great success.[7] Given its comparative hilly isolation yet proximity to downtown Los Angeles and Hollywood, Silver Lake developed its own unique modern/romantic mixture, which this brief history attempts to capture.

Rather than a straightforward chronological or comprehensive overview, this book consists of a series of vignettes devoted to prominent pioneers and

promoters, movie stars and mansion builders, bohemians and visionaries and just plain folk pursuing the American dream. The emphasis is on the area's formative period rather than on more recent developments contributing to Silver Lake and environs' current hyper-hipster status. Some of the stories, particularly regarding famous silent-era filmmakers and screen stars, are well documented but so iconic as to demand inclusion; other lesser-known but richly deserving stories are being shared perhaps for the first time.

Readers expecting a compendium of Silver Lake and the surrounding vicinity's famed modernist architecture by giants such as Frank Lloyd Wright, Rudolph Schindler, Richard Neutra, Gregory Ain, John Lautner and Rafael Soriano, among many others, will have to look elsewhere. I have chosen not to deal with this admittedly important aspect of Silver Lake's history and identity, not because I deem it unworthy of treatment—to the contrary, its study and appreciation are among my greatest passions—but because it is a subject that has been treated copiously elsewhere. This book, instead, focuses on some of the area's more traditionally designed residences, which though far less extensively covered than the modernist icons, are magnificent in their own right, just as representative of the area and often of even greater historical interest because of the people who lived there.

With this personal aspect in mind, descriptions of these and other treasured locations begin with back stories that flesh out the people and places involved and, ideally, inspire readers to learn more about them. Where suitable, they may seek out accessible sites and exclaim: "That's where Tom Mix lived!" or "That's where Laurel and Hardy made their most famous film!" This book partly serves as a guide book. Its main aim, however, is as a historical gloss and a trove of information intended to enrich understanding and appreciation of Silver Lake and surrounding areas—whether one is a longtime resident or newcomer, visiting the place for the first or umpteenth time or content to be seduced from afar by its rich history, multicultural diversity, creative energy and charm.

PARADISE FOUND:
THE LEGEND OF HUGO REID

Local lore maintains that Hugo Reid, a Scottish-born adventurer and sailor, was the first European to make a lasting mark on the later-named Silver Lake area.[8] Reid, as a youth, was described as tall and handsome, with sandy-colored hair and keen blue eyes, possessing a lively nature and a splendid singing voice.[9] Leaving behind an unrequited romance with a fetching lass named Victoria, as well as a promising future as a student at Cambridge University, the impulsive eighteen-year-old (to drown his sorrows) abruptly booked passage for the Americas in 1829. He would spend the next three years as a happy wanderer, exploring the cultures and natural wonders of South and Central America and briefly, with a partner, opening a trading house in Hermosillo, Mexico.

Always game for new adventure, Reid accepted an invitation from a fellow Scotsman, John Wilson, captain of the brig *Ayacucho*, to accompany him on a trip to Alta (Upper) California (as opposed to Baja, or Lower, California). The vessel arrived at San Pedro in the summer of 1832. While the crew loaded a cargo of animal hides and tallow, and with about a week before he needed to return to ship, Reid set out on horseback to explore the surroundings. Twenty-six miles inland lay *El Pueblo de Los Angeles*, which, with a population of only about 1,300, was nonetheless the largest town in Alta California. The dusty speck of a town initially didn't offer much to the well-traveled Reid, so he moved farther inland, going as far as the El Molino mill in what is now Pasadena, before he was called back to ship.

Apparently charmed by the region and attracted by the opportunities the small town offered, Reid returned to Los Angeles in 1834 and started a small

store that became quite successful. It is not known exactly when (or if) he first visited what would become the Silver Lake portion of Edendale, but after settling in Los Angeles, one of his meanderings plausibly took him through the then still largely unspoiled area.

Legend has it that the area's verdant hills and dells made more than a passing impression on the young immigrant. Stirring memories of his native Scotland, Reid purportedly named a portion of the future Silver Lake area Ivanhoe, a reference to the classic historical romance novel by Sir Walter Scott, published in 1820.[10] Besides the Ivanhoe Hills residential development (built in the 1880s as the city's population surged), the Ivanhoe Reservoir (which adjoins the Silver Lake Reservoir) and Ivanhoe Elementary School, Reid's mythic legacy reverberates in local street names. These include: Rowena Avenue, on which Ivanhoe School is located, named after the Saxon heroine of Scott's novel; Scott Avenue, named after Sir Walter himself; and Angus Street, the name that Helen Hunt Jackson would later give to the seaman father of her fictional heroine Ramona (more about this later).[11]

Reid might even have been responsible for naming Edendale, although some bestow that distinction on the Semi Tropic Spiritualists Association, which established a short-lived utopian community in the area (not the last such) in the early 1900s devoted to spreading "modern spiritualism," accompanied by séances, dances at midnight to "roust the spirits" and medium readings.[12] Whether Reid or the spiritualists were responsible, combining the words "Eden," referencing the biblical paradise, and "dale," describing the open valleys that coursed through the terrain, clearly evoked the area's idyllic nature.

Reid's documented connection to the region goes further. In 1834, he had visited Mission San Gabriel Arcángel, one of the two Spanish-era missions in the area (Mission San Fernando Rey de España was the other), which, despite the emancipation of its native inhabitants by the newly independent Mexican government in 1826, still held—at least for non-Indians—a romantic allure. When Reid met the beautiful Doña Victoria, a Gabrielino Indian (as the Tongva came to be called), her San Gabriel Mission connection and her name's reminder of his erstwhile true love were apparently too much to resist.[13] He had to bide his time, however, as Doña Victoria was still married to Pablo Maria, a man twenty-eight years her senior and a respected elder in the Indian community, with whom she had borne four children. After Pablo Maria's death from smallpox in 1837, Reid converted to Catholicism, married Doña Victoria and adopted her children.

Hugo Reid, the Scottish explorer who allegedly gave place names to Silver Lake locales. *Courtesy of the Arcadia Public Library.*

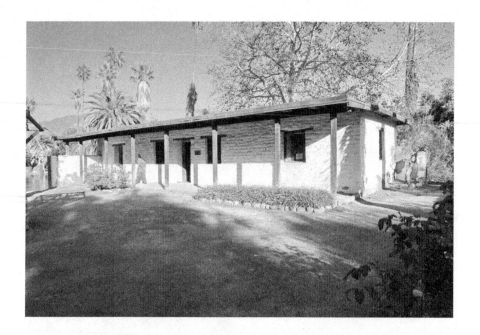

The transplanted Scotsman, and the Los Angeles region, benefitted from the betrothal in more ways than one. Reid's marriage to Doña Victoria brought him a substantial dowry of ranch land, which was bolstered in 1845 by the 13,319-acre Rancho Santa Anita parcel granted to him by Mexican governor Pio Pico. The interracial marriage of the Scottish seaman and mission Indian, moreover, is believed to have inspired the exact same mixed-race parentage of Helen Hunt Jackson's Ramona, eponymous heroine of the blockbuster novel that helped trigger Los Angeles's late 1800s population surge. The book, which became required reading in California schools into the 1950s, was adapted to film four times. The first of three silent versions was directed by D.W. Griffith in 1910 and starred Mary Pickford.[14] The fourth film, a Technicolor spectacular directed by Henry King and starring Loretta Young, hit the big screen in 1936. *The Ramona Pageant*—an outdoor play staged annually since 1923 in Hemet, California—is the longest-running outdoor play in the United States and is the official state play of California.

Unsurprising given his wife's native heritage, but courageous for the times, Reid wrote a series of letters, printed in the *Los Angeles Star* in 1852, sympathetic to the plight of the Gabrielino and the native peoples in general.[15] Reid died in Los Angeles on December 12, 1852. His funeral was held at the old Our Lady Queen of Angels church on Main Street in

Opposite: Hugo Reid Adobe (located at the Los Angeles County Arboretum). *Photo by Michael Locke.*

Left: Hugo Reid at Rancho Santa Anita, from a drawing by Maynard Dixon. *Courtesy of the Arcadia Public Library.*

downtown Los Angeles. Buried initially in the adjacent cemetery, his body was later moved to the Campo Santo Cemetery on North Broadway (now the site of Cathedral High School) and disinterred again and buried in the New Calvary Cemetery in East Los Angeles. I have spent hours there looking for Reid's grave but have never found it.

WILLIAM MULHOLLAND: BRINGING WATER TO A PARCHED AND THIRSTY LAND

It was the growing need for water in a rapidly expanding city that brought the so-named Silver Lake neighborhood into being. The early Tongva settlements tended to be located near the banks of the Los Angeles River or its tributaries. Soon after the pueblo's founding in 1781, the Spanish, African, Indian and mixed-race *pobladores* (first settlers) dug an earthen ditch, called the *Zanja Madre* (Mother Ditch), to channel water from the river. As the population grew during the American period (beginning with the signing of the Treaty of Guadalupe Hidalgo on February 2, 1848, marking the end of the Mexican-American War), various attempts were made to enhance the water system.[16]

In 1857, William Dryden formed the short-lived Los Angeles Water Works Company, which included a brick reservoir at the central plaza and a forty-foot water wheel, which pumped water from the river to the Zanja Madre and from there along wooden pipes to houses along the city's principal streets. A combination of brick and concrete sections and some iron pipes were eventually added, but the Zanja Madre system was the main source of the city's water for the first 120-plus years of its existence.[17]

In 1868, prominent businessmen John S. Griffen, Solomon Lazard and Prudent Beaudry formed the private Los Angeles Water Company (LAWC). Taking over a lease previously granted to the Frenchman Jean-Louis Sansevain, the LAWC contracted with the city, at a cost to the company of $1,500 a year, to supply the city's water. The LAWC laid twelve miles of iron pipe, built a new reservoir and supplied free water to public buildings.

The deal, however—not for the last time in the city's annals—proved to be a swindle, with the company manipulating rent concessions, reducing the lease to $400 a year and lining its owners' pockets at public expense.[18]

The last straw came in 1886, when the LAWC purchased a few acres of marshy land near present-day Crystal Springs Drive in Griffith Park, for which it paid the princely sum of one dollar but which happened to possess a large underground water supply. When the company claimed that the water didn't stem from the Los Angeles River and thus the city had no rights to it, the city sued the LAWC for $225,000 in damages. The suit dragged on for over a decade before settling in the city's favor in 1898, after which the city assumed public control of its water supply as the Los Angeles Water Department (today the Department of Water Power, or DWP).[19]

The story of how Irish-immigrant and self-taught engineer William Mulholland transformed Los Angeles into a modern metropolis is the stuff of legend. Soon after his arrival in the city in 1877, Mulholland landed a job as a deputy zanjero for the LAWC and quickly moved up the ranks. By 1880, he was supervising construction of the new iron pipeline. By 1883, he had been elevated to superintendent, and after the city took control of the company in 1898, Mulholland became first head of the Los Angeles Water Department. Most famously, and controversially to this day, he also would oversee, as chief engineer, the daunting, eight-year construction of the Owens River Aqueduct. Upon completion in 1913, this monumental project that brought Sierra Nevada waters hundreds of miles through newly bored mountain tunnels to the thirsting city both exponentially expanded its water supply and, with the concurrent (some would say underhanded) annexation of the San Fernando Valley, its geographical size.[20]

Mulholland has a major Silver Lake connection as well. In 1889, while still with LAWC and before the Owens River Aqueduct had even been conceived, he began the planning for a reservoir project in the new Ivanhoe Hills residential development in Edendale. The development had sprung up during the so-called Boom of the '80s, spurred by the new rail connections and concurrent real estate frenzy that turned every pasture into a potential harvest of subdivisions. To meet the water needs of this up-and-coming area and the burgeoning city as a whole, construction on two interconnected reservoirs, separated by a spillway, began soon after the city took control of the water supply. Ivanhoe Reservoir, the smaller of the two containments, was completed in 1905; Silver Lake Reservoir went operational in 1906. Combined, they supplied enough water to serve the entire city for twenty-one days.[21]

Silver Lake Reservoir being filled for the first time, 1907. *Courtesy of the USC Riverside Libraries, Special Collections and University Archives.*

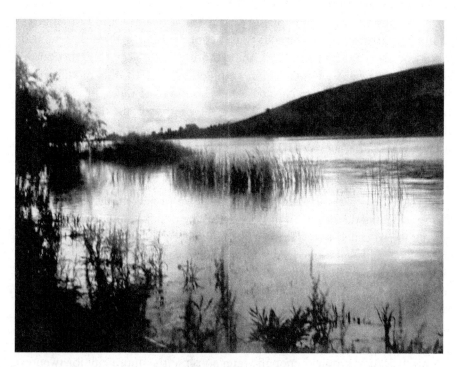

Silver Lake Reservoir in a primal state, 1907. *Courtesy of the Bonadiman Family Archives.*

Though not as colossal a feat as the Owens River Aqueduct, the Silver Lake and Ivanhoe Reservoirs were state of the art. "Mulholland did not design the usual earthen dam," Catherine Mulholland writes in her biography of her storied grandfather, *William Mulholland and the Rise of Los Angeles*. The reservoirs were lined with concrete walls, three feet thick and reinforced with steel plates, extending from bedrock to water level. Mulholland also introduced a hydraulic sluicing technique that threw up the mud being dredged from the bed onto the dam walls that shored up the reservoir. Although not as controversial as that which would attend the aqueduct project, this innovation still created a stir in engineering circles. One member of the American Society of Civil Engineers declared the method impractical, arguing that water pressure would not be able to force heavy material through the pipes, while another defended the procedure as having been successfully applied in gold dredging. "Nothing new in it," Mulholland concurred. "It is done every day, and I'm surprised that any one should question so obvious a fact."[22]

Beyond the practical value of the reservoirs, to the immediate area and city as a whole, they became the focal point of the community, and their lake-like beauty became a major enhancement. Lots for sale with "lake" views commanded the highest prices as new residents flocked to the subdivisions of the township that gradually, and appropriately, became known as Silver Lake.

Still clearly the topographical heart and soul of the community, the reservoirs are currently in a state of flux. With the rise in environmental consciousness and governmental regulation in recent years, open-water reservoirs have fallen out of favor. Besides the extensive loss of water to evaporation and the expense of purification due to airborne pollution, exposure to the elements has been shown to produce chemical reactions with carcinogenic consequences. After initial plans in the 1980s to cover all the city's open reservoirs met with stiff resistance from the communities concerned, the Department of Water Power has begun to transfer reservoir water to underground storage tanks, leaving the reservoirs for potential recreational use. In Silver Lake specifically, the Silver Lake Reservoirs Conservancy (previously the Committee to Save Silver Lake's Reservoirs), a nonprofit community group formed in 1988, has been at the forefront of efforts to preserve and enhance the reservoirs' "historical, aesthetic, ecological and recreational benefits."[23]

As for William Mulholland, the man hailed in his own day as a Mosaic figure who "struck rock to bring water" and "stood on Mount Nebo and pointed to the Promised Land," his name famously graces movie-titled, star-

studded Mulholland Drive at the crest of the Santa Monica Mountains and the Hollywood Hills.[24] His legacy even more directly lives on in Silver Lake, through the twin reservoirs he helped construct and the white rose–ringed Mulholland Fountain at the southeast (borderline Silver Lake) corner of Los Feliz Boulevard and Riverside Drive.

HI-YO HERMAN SILVER!
SILVER LAKE'S NAMESAKE

One can be pardoned for assuming that the Silver Lake Reservoir and community got their name from the former's shimmering waters, particularly when gazing at them in dawn's early light. In fact, the name honors Herman Silver, a German Jewish immigrant who rose to prominence in Los Angeles in the late 1800s. He was elected to and became president of the city council in 1896 and appointed acting mayor in 1898 and president of the Los Angeles Water Commission in 1902, among numerous other achievements.

Much of what is known about Herman Silver can be attributed to Hynda Rudd, who served as Los Angeles's first official city archivist, a position she held for more than twenty years, beginning in 1979. As a graduate student at the University of Utah in the late 1970s, Rudd wrote her master's thesis on the Jewish history of the American West during the nineteenth century.[25] A self-proclaimed "Mormon Jew," she decided to rediscover her Jewish roots in her Mormon-dominated native state. Stumbling on Silver in her research, she "found him to be far different than the typical pioneer; he was not searching for a new identity; he wasn't a peddler looking for opportunity in the largely undiscovered West. And he wasn't looking to strike it rich in mining for gold or silver."[26]

Herman Silver was born on July 21, 1830, in a small village about 140 miles southwest of Hamburg, Germany.[27] He was one of six children. According to rabbi and historian William Kramer, Silver was a bright child in both secular and Hebraic studies and aspired to become a rabbi. He was also a sickly child, however, who often missed school and passed his time

reading books in the family library. For health reasons, his parents thought he would be better off in the warmer climes of the American Southwest. He arrived in the New World, alone, in 1844. Only thirteen years old but nearly six feet tall, the gangly youngster had met a Spanish-born Catholic priest from Montreal, Father Gerard, on the boat trip over, and the two became instant friends. Silver followed along with Father Gerard to his home in Montreal, where the priest offered him English lessons in exchange for Silver's teaching him Hebrew. During Silver's two-year stay in Canada, the restless youngster also managed to travel extensively throughout New York, the Midwest and the Deep South.[28]

In 1860, while living in Peru, Illinois, the now thirty-year-old Silver met his future wife, Elizea Post, and his career began to blossom. An ardent antislavery Republican, he met Abraham Lincoln and served in the Internal Revenue Service from 1863 to 1864 and as an attorney from 1866 to 1867, later becoming acquainted with future president Ulysses Grant and General John C. Frémont. Although he never served in the military, for health reasons, Silver was an active recruiter of fighters for the Union cause during the Civil War.

To help with his lung problems, Silver moved in 1874 to Denver, Colorado, which had gained a reputation as a health resort. As high as one-third of the state's population had come for health reasons, many—as they would later to Los Angeles—for the treatment of the scourge of the era: tuberculosis. In Denver, Silver was appointed registrar of the United States Land Office and became national deputy for the Colorado branch of the Union League, originally formed as a beacon for the emancipation of blacks. Seemingly of indefatigable energy despite his lung condition, Silver became superintendent of the Denver Mint from 1877 to 1885, while also serving as manager of the *Denver Tribune* and treasurer and auditor for the Denver and Rio Grande Railroad.

Hoping his health would fare better in sunnier Southern California, and with a new position as secretary-treasurer of the Atchison, Topeka and Santa Fe Railroad (AT&SF), Silver moved to the company's San Bernardino offices in 1887. It was a fortuitous move, for him and Los Angeles, as the railroad's soon-to-be-completed second transcontinental line to Los Angeles would prove crucial to the city's late 1800s population boom and would draw Silver to Los Angeles to be closer to the company's chief business interests.

Little is known about Silver's early activities in Los Angeles other than his continued work for the AT&SF and, as reported in the Jewish press, his involvement with a local Jewish community that boasted some of the city's

most prominent business leaders. One of the more noted of these, Harris Newmark, briefly mentions Silver twice in his classic memoir, stating that Silver "and J.F. Crank in 1887 obtained a franchise for the construction of a double track cable railway in Los Angeles" and that Silver "had not only an association as a friend of Lincoln, but was a splendid type of citizen."[29]

Silver's political ascension began in 1896, when he first ran for the Los Angeles City Council in the Fourth Ward as a Republican (bearing in mind that in the Progressive era at the turn of the century, Republicans were ideologically closer to today's moderate Democrats). Los Angeles was then divided into nine wards, with the first election under the ward system held in 1889 and the last in 1906. As the population approached 100,000 by the turn of the century, most of the citizenry, including its wealthiest members, then lived in or near downtown. The Fourth Ward, with a population of about 4,500, was bordered by downtown's Seventh, Main and Washington Streets (now Washington Boulevard).

The influential, if then also quite conservative, *Los Angeles Times* threw its weight behind Silver's candidacy. Punning that "Fourth Ward citizens are SOLID ON SILVER" and his "sterling qualities," the paper more informatively touted the candidate's "eminent services to the government of the United States in various positions of honor and trust, covering a long period of years."[30] The *Los Angeles Record* also backed Silver, stating in an editorial: "In the Fourth Ward the machine politicians have practically abandoned the candidacy of Mr. Riley and are concentrating to elect Long. The situation demands that all residents of the ward who desire to have the ward properly represented must rally actively around Herman Silver, whose election as councilman has become a necessity."[31]

Silver was elected by a plurality in a multi-candidate field, and in his first day in office, the novice politician was elected president of the then Republican-led council. Although initially under constant attack from the Democratic opposition, even Silver's rivals admitted that he was straightforward and honest, "opposed to chicanery, petty larceny and political skullduggery."[32] His integrity and conciliatory skills were affirmed in his election to a second Los Angeles City Council and council president term two years later, the latter selection this time by acclamation.

During his four years on the council, and a period as acting mayor in 1898, Silver was frequently mentioned as a viable candidate for the mayor's post outright. At the Republican nominating convention of 1900 (today, mayoral and council offices are technically non-partisan, and their terms last four years), he was picked by a slim margin as the party's mayoral candidate

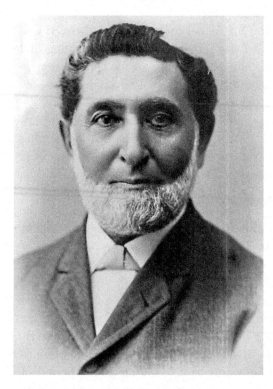

Los Angeles City Council president Herman Silver, 1897. *Courtesy of Hynda Rudd.*

over Charles Cassat Davis, president of the Board of Education. In the mayor's race itself, between Silver and Democratic candidate Meredith Snyder, Los Angeles voters were given seemingly a clear choice.

Besides Silver's array of prominent endorsements—including those of the League for Better Government, the Citizens of the Fourth Ward and the Republican Party—the election was, according to the *Los Angeles Times*, "essentially a fight for decency and order, clean municipal government and the thorough enforcement of law on the side of Mr. Silver, and for jobbery, corruption and the domination of the disreputable elements of society on behalf of his opponent."[33] The *Los Angeles Express* was even more vociferous: "If Meredith P. 'Pinky' Snyder were elected Mayor [he had been once before, in 1896], he would 'fall down before the gang.' He would be clay in the hands of the potter. He would do the bidding of bad men as a matter of course, not alone for the reason that he is a man of weak character and of small mental caliber."[34]

Silver's establishment backing notwithstanding, Snyder was reelected mayor; in fact, he served four two-year terms in all: 1896–98, 1900–04 and 1919–21. Several possible factors for Silver's defeat have been suggested: at nearly seventy years old and in fragile health, he may have been deemed not physically up to the job. Anti-Semitism, which was beginning to rear its head in the wake of the eastern European immigrant wave of the turn of the century, may also have played a part. After the mayoral election, Silver retired briefly from public life, but his preeminent importance to Silver Lake specifically was only just beginning.

Showing a conciliatory side himself, in 1900 Mayor Snyder appointed Silver to the city's Board of Water Commissioners, where, as with the city council, he was selected the board's president in 1902. This was no token appointment, for water issues, as discussed in the previous chapter, had become of paramount importance to fast-growing Los Angeles. Silver had even gotten his feet wet on the issue during the battle in the 1890s between the city and the privately controlled Los Angeles Water Company, when he reportedly "sprang into the breach" on the side of the city.[35]

But just as things were coming to a boil with the Owens River Aqueduct proposal, Snyder suddenly reversed course; when Water Commission membership was reduced in 1903, he did not retain Silver's services. The *Los Angeles Herald* implied that the decision was a form of delayed payback for Silver's opposition in the mayor's race: "The turning down of Herman Silver as head of the Board of Water Commissioners was a specimen of mighty small peanut politics, of which even Mayor Snyder ought to be ashamed."[36] The politics were more than small peanuts, however, if Silver's dumping had been a way of removing a possible roadblock to the impending aqueduct project.

What position Silver might have taken on the project must remain speculative; it's doubtful he could have made a difference in any case, even if he'd wanted to. But given the corruption charges that have been hurled, then and since, at other water commissioners, notably electric-car pioneer Moses Sherman, it may have been a blessing for Silver's lasting reputation that he was cashiered when he was.

His career of civic involvement and notoriety was not yet behind him. In 1903, Governor George C. Pardee appointed him head of the California State Bank Commission, a position he held for two terms until his retirement in 1908. The year before, culminating a lifetime of "sterling" public service and on William Mulholland's personal recommendation, Silver's name was bestowed on one of Mulholland's recently completed reservoirs and from there on the surrounding area.[37] He had six years to enjoy the honor. Herman Silver died of a heart attack on August 19, 1913, leaving behind Elizea, his wife of over fifty years, and a daughter, Cora. He was eighty-three.

EARLY PIONEERING FAMILIES: THE BONADIMANS AND PASSARINIS

The marriage-related Bonadiman and Passarini families were among the earliest to put down roots, around 1889, in the area to which Herman Silver would soon give his name. Fortunately, we have the personal records kept by Mary Bonadiman, eldest daughter of Carlo and Domenica Bonadiman, to flesh out the joint family's history. Mary's meticulously kept handwritten notes, letters, interviews and photos have been passed down through the generations, currently resting in the hands of her great niece, Carol Hagedorn, a Silver Lake native who still lives in the neighborhood. These precious documents provide a rare window into the background of one of Silver Lake's pioneer families and into what life was like in the area in general at the turn of the twentieth century.[38]

According to Mary's records, Carlo's parents, Emanuele and Moira Bonadiman, with Carlo and his siblings Vegilio, Rachele, Raphael, Florian, Santa and David, departed from the little town of Ambler in the Austrian Alps of Tyrol in 1865. They were among a group of Austrian families sent off to aid in the re-colonization of Mexico, then under the rule of Maximilian I, younger brother of Emperor Franz Joseph I of Austria. Napoleon III of France, who had invaded Mexico in 1861, had schemed with Franz Joseph to put Maximilian on the Mexican throne in 1864. To help legitimize the takeover, hundreds of Austrian citizens were compelled to leave their homes and settle in the new colony.

The Bonadimans boarded a vessel bound for Veracruz, where they were placed on a barren stretch of land and expected to eke out a living. Emanuele,

who had held the position of forester and game warden in the Old World, found it difficult to find any kind of work in the nearby Mexican towns. Conditions were further complicated by the Mexican rebellion against Maximillian, led by Benito Juarez. The combination of economic hardship and domestic turmoil led the Bonadimans, along with other Austrian families, to leave Mexico in search of a better life across the border in Texas.

No sooner had the Bonadimans departed, however, than Mexican colonial gendarmes captured and jailed them. Sympathizing with their plight, Maximillian's wife, Carlota, persuaded him to let them go—just in time, it turns out, as Maximillian would soon be captured by Juarez's forces and executed (Carlota, who was believed to be mentally ill and had left for Europe just before, was spared).

The Bonadimans remained in the (once again) independent, but still tumultuous, Mexico until 1885, when they set off once more for Texas and, this time, finally arrived in San Antonio. Along the way, their youngest son, David, died. Another son, Santa, passed away, and another daughter, Elvira, was born during their two-year stay in Texas.

Besides the personal tragedies, life wasn't much easier on their hardscrabble Texas farm than it had been in Mexico. "My grandmother didn't like the snow and she didn't like the snakes up in the trees right around the house," Mary is quoted as saying in her records. After an exploratory trip to California to gauge the opportunities, Emanuele left with Carlo and Rachel for Los Angeles in 1887. They found temporary accommodations near the old Plaza Church, across from today's Olvera Street, and worked at various odd jobs—Emanuele doing street work and Moira doing laundry and housekeeping—until they saved enough money to send for the rest of the family.

Still rural folk at heart, the Bonadimans were drawn to the rolling farmlands of Edendale. In 1889, they rented a sixty-acre ranch from George Smith above Sunset Boulevard between Angelus Avenue and Benton Way, where they planted wheat and hay and raised horses, cattle, hogs and chickens. A canal from the Los Angeles River ran through the land, for domestic use and to irrigate the crops as well as the existing groves of olive, fig, eucalyptus and orange trees.

Other families had joined the Bonadimans in the move from Texas, among them Antonio and Francesca Passarini and their daughter, Domenica. In 1891, Carlo Bonadiman married Domenica Passarini, and together they had four children: Mary (1892), Rose (1894), Charles (1897) and Joseph (1903). Mary writes of growing up at the ranch with the extended family: "We would hitch up a wagon and we'd take it to town where we sold our products and

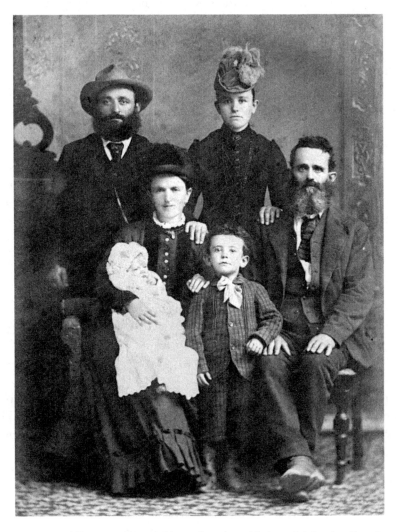

Antonio and Francesca Passarini (seated) posing with Antonio's brother Bertolo and the Passarini children, Josep, Domenica (standing) and Angelo. *Courtesy of the Bonadiman Family Archives.*

Opposite, top: The Bonadiman family in Los Angeles, 1890. *Courtesy of the Bonadiman Family Archives.*

Opposite, bottom: The Bonadiman family home at 1533 McCollum Street, 1905 (still standing today). *Courtesy of the Bonadiman Family Archives.*

bought what the farm didn't produce. My brothers and sisters would peddle milk ourselves; the going price was five cents a pint, seven cents a gallon."[39] To navigate the steep hills, residents of the area developed a unique form of conveyance. A team of mules pulled a cart on the uphill route, and going downhill, the mules were put on the cart with the passengers for a free ride while coasting downhill.

As with many early Silver Lake tales, the Bonadiman-Passarini saga mingles the agrarian past with the motion picture future. For, in addition to functioning as a working farm, the property doubled as a set for many silent-era movies in the early 1910s. Mary recalls her mother preparing breakfast and lunch for "the people making movies" and watching Mack Sennett's Keystone Kops, Roscoe Arbuckle and other slapstick comics as they went through their zany antics.

> *The very first movies* [in Silver Lake] *ever made were probably filmed on our ranch. I remember them finally burning down our old rented house, which by now was in a poor state. A little short guy in a Mabel Normand movie had a bomb tied to himself as he ran through the house and pretty soon the house went up in flames. My grandmother, who was sitting on the front porch, started to cry. I asked, "Why are you crying?" She replied, "The old home we lived in so many years is going up in smoke."*[40]

Ironically, the movie industry, and the real estate boom it helped spur, eventually did in the Bonadiman ranch, as the property was subdivided. The family moved up the hill to a four-bedroom house that Carlo had recently completed at 1533 McCollum Street. The house is still standing today.

THE MULTI-TALENTED WATSONS

As for movie industry connections, the Bonadimans had nothing on the Watsons. James Watson, patriarch of the prodigious Watson family, and his wife, Amy Kate Ball, were also among the earliest settlers of the Silver Lake area, arriving in 1901. James was born in London, England, in 1863. In his late teens, he became a follower of General William Booth, founder of the Salvation Army, and in 1882 left England with Brigadier Gideon Miller to help spread the word in Ontario, Canada. There, James met his future wife, Amy Kate Ball, who was instrumental in starting the Salvation Army's first home for unwed mothers in Canada. (In those days, the majority of the group's converts were alcoholics, prostitutes, drug addicts and other "undesirables" not generally welcome in polite Christian circles.)[41]

As was typical of Salvationist missionaries of the period, James and Amy didn't stay in any one place very long; their goal was to reach as many souls as possible, believing that Judgment Day was at hand. Before they left Canada, the first four of their nine children were born: Herb, James Caughey, George and Ethel. The growing family traveled first to Denver and then to Salt Lake City, doing evangelical work as they went.

The Watsons finally settled in an Edendale section, just southeast of Silver Lake, which would become Echo Park. They rented a house at 1717 Morton Avenue near Sunset Boulevard and Echo Park Avenue (their house is also still intact). Exemplifying the region's growth and Edendale's emerging bohemianism, Echo Park Avenue was already "famous for its one-

horse streetcar and was one of Los Angeles' busiest streets, serving a very progressive neighborhood," Coy Watson Jr., son of James Caughey (later Coy Sr.) wrote in an unpublished memoir.[42] While in Los Angeles, James Sr. and Amy Kate Ball had five more children: Amy, William, Victor, Hazel and Johnny. Hazel died at age twelve, her death attributed to rat poisoning, and Johnny died as an infant from pneumonia.

When James Sr. wasn't doing God's work, he amused himself with playing the violin and practicing photography. Purchasing one of the early Eastman Kodak cameras and learning how to use it from a United States Army manual, he appropriated the family pantry for a darkroom. Most significant for the world at large, he passed along his photography skills to ten of his male descendants, six of whom worked for the *Los Angeles Times* or *Times*-owned newspapers, recording a century of the region's history.

His son George was the first professional photographer in the family, working first as a staff photographer for the *Los Angeles Times* starting in 1917 and then, in 1927, moving on to manage Pacific and Atlantic Pictures, precursor to United Press International. George Watson's priceless legacy is archived in a collection of 600,000 images at the Watson Family Photo Archive in Glendale, California.

Two other sons, William and Coy Sr., were the first to embark on careers in Hollywood. William had a long career as a film editor, writer and director on many films up to the 1950s. Coy Sr. was a jack-of-all-trades, working as an actor, stunt rider, special effects innovator, key grip, assistant director and, for a time, casting director for Fox Studios. In special effects, he achieved a measure of fame for engineering the famous magic carpet scene in Douglas Fairbanks's 1924 film *The Thief of Baghdad*. Of equal importance, he managed the acting careers of his nine children.

As for Coy Sr.'s name change, Coy Jr. writes, "My father changed the name from Caughey to Coy because it was easier to pronounce. It was a good name for Dad in the movie game and a good name for me in the news business—easy to spell and remember." Of the Echo Park/Silver Lake area, Coy Jr. recalls that, other than bustling Echo Park Avenue, "there weren't many good roads then, and riding on horseback was the easiest way to get around. By the time he was twelve, [my dad] was delivering mail for the United States Postal Service on his little white pony, Billy." Not earning enough to support the family, he "moved up" to delivering packages for the Vilde Paris department store and traded in his horse "for a one-cylinder Thor motorcycle, which put him in the 'jet set' of his day!"[43]

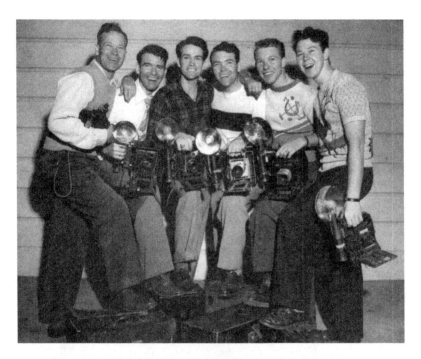

The Six Watson Brothers photography company, 1955. *Left to right*: Coy Jr. Harry, Billy, Delmar, Garry and Bobs. *Courtesy of the Watson Family Photo Archive.*

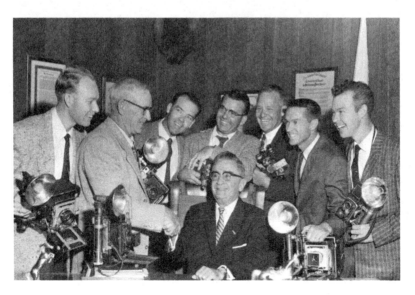

Watson family photographers with Sheriff Eugene W. Biscailuz, 1958. *Courtesy of the Watson Family Photo Archive.*

George Watson, dean of Los Angeles news photographers, during his stint as second staff photographer of the *Los Angeles Times*, 1919. *Courtesy of the Watson Family Photo Archive.*

Opposite, top: Watson family photo in 1932. *Left to right*: Bobs, Garry, Delmar, Bill, Harry, Louise, Gloria, Vivian and Coy Jr. *Courtesy of the Watson Family Photographic Archive.*

Opposite, bottom: Coy Watson Sr., cutting hair. *Courtesy of the Watson Family Photo Archive.*

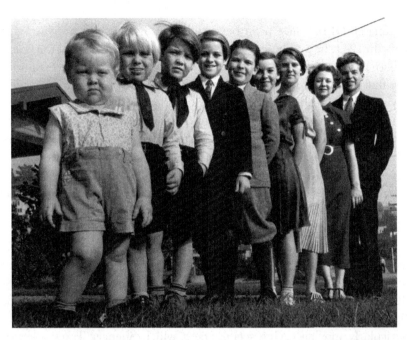

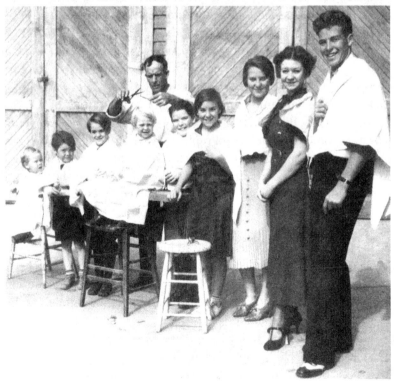

Timing could not have been better for Coy Sr.'s and his progeny's film careers. In 1911, he purchased a vacant lot on Berkeley Avenue at the border of Echo Park and Silver Lake, building a home for his ever-expanding family that eventually numbered nine children: six boys and three girls. The following year, Mack Sennett brought his Keystone Film Company to town, purchasing an abandoned grocery store on Glendale Boulevard two blocks away. It wasn't long before the studio took notice of Coy Sr.'s stable of horses and his attractive houseful of children, both of which Keystone was wont to use in its comedy shorts.

After getting their start with Keystone, the nine children—Coy Jr., Vivian, Gloria, Louise, Harry, Bill, Delmar, Garry and Bobs—would appear in over one thousand movies (and eventually television shows) into the 1940s and beyond. Delmar alone appeared in more than three hundred films, including *Heidi* (1937), in which he shared the screen with Shirley Temple. Garry appeared in *Mr. Smith Goes to Washington* (1939), *Knute Rockne, All American* (1940) and *The Exile* (1947). Bobs starred as "Pee Wee" in *Boys Town* (1938) with Spencer Tracy and Mickey Rooney. His role is most remembered for a particularly moving crying scene, about which Spencer Tracy allegedly remarked, "There goes my chance for another Academy Award."[44] Bobs went on to play in many television shows in the 1950s, '60s and '70s, including *The Twilight Zone*, *The Beverly Hillbillies*, *Green Acres*, *The Fugitive* and *Lou Grant*. He remained an actor into middle age, eventually retiring from show business and becoming a Methodist minister.

Though their initial fame came as childhood actors, five of Coy Sr.'s sons—Coy Jr., Harry, Billy, Delmar and Garry—ultimately followed George's footsteps to become full-time photographers. By the 1940s and '50s, four of the brothers were working for Los Angeles newspapers, including the *Los Angeles Times*, *Los Angeles Daily News* and *Los Angeles Mirror*. In the 1950s, the five brothers added Bobs to the mix and formed a commercial photography business acrobatically called the Six Watson Brothers. Delmar started his own photo studio in 1967 and began archiving the family's photo collection. After ill health forced his retirement, the archive was moved from Hollywood to Glendale. Delmar Watson died in 2008. His nephew Daniel, Garry's son, carries on the family's photography tradition at several community newspapers and for television, as well as maintaining the family's archives with Delmar's widow, Antoinette.

The Watsons of Silver Lake/Echo Park have deservedly been called the "First Family of Hollywood" for their pioneering work in the movie industry.[45] Nine decades and more than one thousand movies (and television

shows) later, they finally received a long-overdue star on the Hollywood Walk of Fame on April 23, 1999. Coy Jr., Delmar, Garry, Louise (Watson Roberts) and Billy were on hand for the ceremony. Ailing brother Bobs couldn't make it but "tuned in" from home by cellphone. If you wish to pay your respects, the star is located at 6674 Hollywood Boulevard.

6

BIG RED CARS: BUILDING A
FOUNDATION FOR THE FUTURE

The census of 1870 must have been depressing news to the civic boosters of Los Angeles. With a population of only 5,728 and ridiculed as "Queen of the Cow Counties," the so-called City of Angels was a decidedly minor Wild West outpost compared to cosmopolitan San Francisco with a population, thanks to the gold rush and the country's first transcontinental rail connection, approaching 150,000.[46]

The importance of a rail line connecting Los Angeles to the rest of the nation was not lost on the city's powers that be; indeed, without it Los Angeles seemed doomed to anonymity. Making matters worse, the Southern Pacific Railroad planned to bypass the town altogether, constructing a route from San Francisco through the San Joaquin Valley and then eastward. The company would relent only if Los Angeles agreed to subsidize construction costs amounting to the then hefty sum of $600,000. A bond measure was placed on the city ballot in 1872, and boosters mounted a furious campaign, promising that a connecting line to San Francisco would make Los Angeles the "Metropolis of Southern California."[47] The measure passed by a margin of three to one.

The spike connecting Los Angeles with San Francisco was driven on September 6, 1876, launching the first migration wave to Southern California, one that grew to a tsunami when two direct transcontinental lines to Los Angeles were completed: the first, by Southern Pacific, in 1882 and a competing line, by Herman Silver's AT&SF, in 1885. Intense competition between the two railroads created a rate war that reduced prices

from Kansas City to as low as one dollar by 1887. Between 1870 and 1880, the population of Los Angeles doubled to over eleven thousand, and by 1880, it had nearly quintupled to over fifty thousand.

The bargain-basement ticket prices amounted to a loss leader for the train companies: a marketing strategy to stimulate sales of more profitable goods, namely land—land that the rail barons were snapping up at cheap prices thanks to the subsidies granted them for building their lines. The Los Angeles Chamber of Commerce, founded in 1888, became de facto partners with the rail and real estate interests that began touting the region, with *Ramona's* unintended assistance, as the Promised Land. As Tom Zimmerman describes in *Paradise Promoted: The Booster Campaign that Created Los Angeles, 1870–1930*:

> *It had been quite a campaign, unique in American history. An irrelevant cow town like hundreds of others in the West, with no reason at all to become a major city, was transformed in forty years to the fifth-largest city in America, with an industrial base that would significantly aid in the defeat of the Axis enemy in World War II, the busiest harbor on the West Coast and the home of the entertainment and aviation industries. It would also be the butt of countless jokes due to the excessive campaign, but that didn't keep them from moving to Los Angeles.*[48]

The new arrivals were fair game for the developers. Wheat and barley fields were promoted as future cities and sold at inflated prices while short rail lines were being built throughout Southern California. By 1888, the influx briefly came to a standstill, as disappointed speculators discovered that their "investment" lacked the necessary urban amenities and was useful only for farming. The pace picked up again as infrastructural improvements were undertaken, capped by one of the wonders of the modern age: the electric streetcar.[49]

The first commercially viable electric streetcar was the invention of Frank J. Sprague. Having worked with Thomas Edison in the development of the electric light bulb, Sprague founded the Sprague Electric Railway and Motor Company in 1884 and began manufacturing electric rail cars. One of his first customers was a group of Kansas investors who had recently purchased a streetcar line from Charles Howland of Los Angeles. Howland's line hoped to serve a farming area northwest of Vermont Avenue and Pico Boulevard once it was subdivided for development, but the cars were inferior to Sprague's new model and proved unreliable. The Kansas group's switch to Sprague's machines would be the first step toward what would become the largest interurban transportation system in the world.[50]

The next big step was taken by brothers-in-law General Moses Sherman and Eli P. Clark, who purchased the Howland line in 1890. They quickly set about acquiring other horse-drawn and cable-car lines, which they unified under the Los Angeles Consolidated Electric Railway (LACE). Their next project was building a line between Los Angeles and Pasadena, which, upon completion in 1895, became the first truly "interurban" rail line in Southern California.

Buoyed be their success, Sherman and Clark planned a second extended line from Los Angeles to Santa Monica, an idea the press immediately satirized by casting it in terms of another General Sherman's notorious "March to the Sea." The plan indeed proved overly ambitious: Sherman and Clark fell behind on their bond payments, and the assets of their Pasadena line were acquired by a group of California's biggest power brokers, including banker Isaias Hellman, Southern Pacific president Collis Huntington and his nephew Henry Huntington (of Huntington Library and Gardens fame).[51]

The Santa Monica and other lines would eventually be built, completing an expanding urban transit system that, by the early 1900s, also passed through what would become the Silver Lake and Echo Park sections of Edendale. Under the banner of the Pacific Electric Railway and headed by Henry Huntington, the system became known, from its trains' color scheme, as the Red Car Line. Another new line, part of Leslie Brand's Los Angeles and Glendale Electric Railway, crossed the Los Angeles River between Edendale and Glendale via the Fletcher Drive Viaduct, constructed in 1904. Brand (of Brand Park and Library fame) sold the Glendale line to Pacific Electric in 1906, and by 1910 the company's vast system of "Big Red Cars," light rail and buses had become the envy of the world—literally stretching from the mountains to the sea, linking cities with orange groves, traversing mountain ranges and skirting the Pacific Ocean.

Before this extensive network could reach its full potential, however, Brand's original timber trestle bridge had to be replaced. Only twenty-four feet wide and producing major traffic jams during rush hour, the bridge eventually collapsed in 1927. Voters subsequently approved a $1.6 million bond measure for a new Hyperion Viaduct built with concrete arches supplemented by two smaller concrete viaducts, an electric railway underpass and a one-street-grade separation—an engineering marvel in its day.[52]

At its peak, the Red Car Line through Silver Lake made 171 scheduled runs on weekdays, all single cars, as the line never enjoyed multiple-unit operation in spite of high patronage. With declining ridership after World

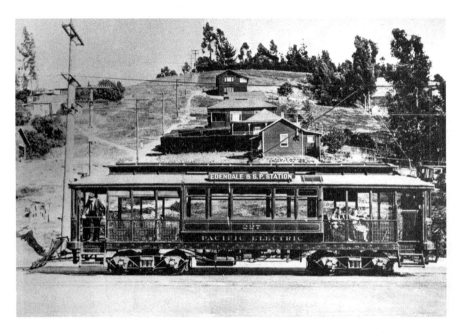

Edendale Red Car southbound on Glendale Boulevard. *Courtesy of the Watson Family Photo Archive.*

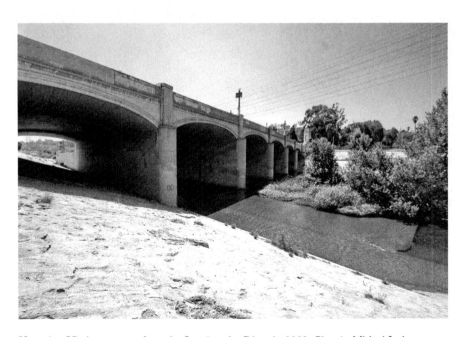

Hyperion Viaduct as seen from the Los Angeles River in 2009. *Photo by Michael Locke.*

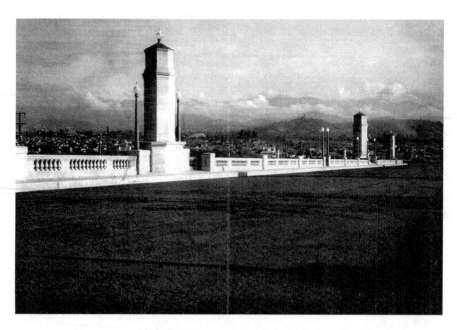

Hyperion Viaduct crossing the Los Angeles River 1930. *Courtesy of the Los Angeles City Historical Society Archives.*

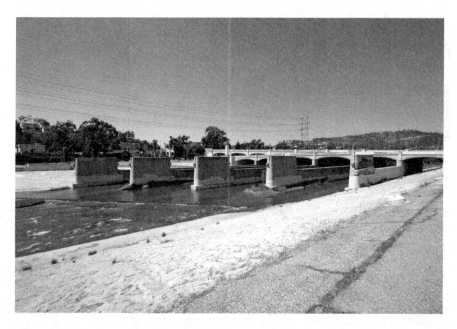

Five concrete supports are all that remain of the rail bridge that supported the Red Car rail line where it crossed the Los Angeles River. *Photo by Michael Locke.*

War II, due to the rising popularity of the automobile, Red Car operations were reduced to regular service only Monday through Friday and limited service on Saturday. The Big Red Cars ceased running through Silver Lake and Echo Park in 1955, when the Glendale Line was decommissioned to build the Golden State (or Interstate 5) Freeway.

Los Angeles's lead in replacing rail lines with expressways, initially seen as a sign of progress, would soon turn the city into a model of myopia for its precipitous destruction of a once remarkably efficient transportation system. The 6,200 trains operating daily were traded in for hundreds of miles of concrete carrying millions of gas-guzzling, pollution-spouting motor vehicles at ever slower speeds. By the 1950s, "smog" and "traffic congestion" were already Los Angeles's new middle names. "Condemning the citizenry to their cars," Tom Zimmerman notes about the railroad-for freeway exchange, "was the biggest mistake in the history of Los Angeles."[53]

Ironically, most of the freeways, then and now, run along previous inner-city and longer-range rail lines, which themselves followed the dirt roads of the Spanish missionaries' El Camino Real (king's highway), which in turn may have made use of old Indian trails. Given this multi-layered history, it's fitting that reminders of the Red Car Line remain in Silver Lake today. These include the old bridge supports depicted on the previous page and several concrete footings on a slope above the Arco Station at Riverside and Fletcher Drives, whose uncanny appearance has led locals to dub the site Silver Lake's "Stonehenge."[54]

There's another, more practical silver (Lake) lining to the Big Red Cars' elimination. After a long battle of community activists led by Silver Lake resident Diane Edwardson, with crucial assistance from the Santa Monica Mountains Conservancy, a secluded stretch of the former Red Car Line above Fletcher Drive, known as the Corralitas property, may be spared a massive condominium complex and instead be turned into a beautiful park.[55]

FROM RED CARS TO ROADSTERS

Los Angeles's love affair with the automobile predated Henry Ford's introduction of the Model T in 1908. The Auto Club, forerunner of the Automobile Association of America (AAA), was founded in Southern California in 1900. What the Model T's affordable price of $825 accomplished was to turn what was considered a rich man's toy into a commodity within reach of the middle class.

Demand for Ford's invention rose throughout the 1910s and '20s, reaching a production peak of over 15 million cars in 1927, a record that stood for the next forty-five years. Presidential candidate Herbert Hoover's slogan, "A chicken in every pot and a car in every garage," evoked the (pre-crash) optimism of the times, which was nowhere better realized than in Los Angeles.[56] In 1929, the United States ownership of an automobile was one for every 5.13 persons. In Los Angeles, it was one for every 3.20 persons, the highest per capita of any city in the world.[57]

While the railroads continued to thrive through the early 1900s, their days were clearly numbered—by the automobile juggernaut and their owners' greed. Resentment over the rail companies' monopolistic power, in California especially, remained high. Frank Norris's 1901 muckraking classic *The Octopus* focused on the state's "Big Four" rail barons: Leland Stanford, Collis Huntington, Charles Crocker and Mark Hopkins. Progressive Republican Hiram Johnson was elected governor in 1910 on an anti-railroad platform, touring the state in an open automobile during the campaign and establishing a regulatory railroad commission once in office.

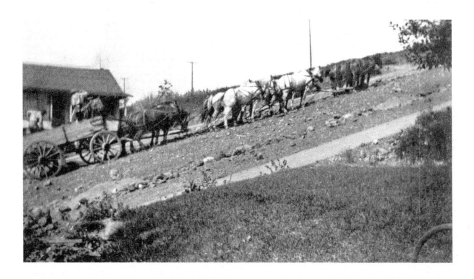

Road Building on Clifford Street, 1914. *Courtesy of the Bonadiman Family Archives.*

The family car, meanwhile, in addition to its affordability, offered a new degree of individual freedom, both for inner-city and long-distance travel. Increased vehicular traffic, of course, increased the need for more and more roads. Although the freeways, as indicated above, would traverse well-worn historical trails, Los Angeles's first cars traveled along more off-the-beaten paths, many with tree stumps that tripped up horses and upset wagons. (The expression "I'm stumped" originated from this experience.)[58]

Edendale, with its hillside terrain and river running through it, presented a particular challenge. Mary Bonadiman has described her family's innovative method in the early 1900s of navigating the steep inclines by mule. Early methods of road construction, compared with today's techniques, were similarly primitive. In this circa 1914 photo, for example, a mule team pulls a wagon up steep Clifford Street as workers shovel hot asphalt onto the ground.

New equipment, such as the motorized asphalt-paving machine, invented in 1929, greatly facilitated the construction process. The 1930 upgrading of the Fletcher Drive Viaduct of 1904, connecting Silver Lake and Glendale, was another major achievement. Other improvements included a new Sunset Boulevard Bridge over Silver Lake Boulevard, completed in 1904. The new bridge was eighty feet long, compared to the old one's fifty-foot length. The expense was divided between the city and the railroad companies but with the city (déjà vu?) shouldering the bulk of the cost: $17,200 compared to the railroads' $7,850.[59] As for its efficacy, the *Los Angeles Times* reported, "The

Silver Lake Reservoir, 1927. *Courtesy of the Chris Nichols Collection.*

reconstructed bridge was necessitated by the difference in grade between Glendale and Sunset Boulevards with the tracks of the Glendale Electric Line running down Glendale Boulevard, and those of the Los Angeles Pacific occupying a portion of Sunset Blvd."[60]

Sunset Boulevard, of course, is much more than Silver Lake's main business drag. Especially with the coming of the film industry in the 1910s and '20s and its highlighting in Billy Wilder's like-named 1950 film, it would become (as it remains) one of the most famous streets in the world. It is also one of the longest urban passageways and, for Los Angeles, the most educational. In its twenty-two-mile traversal from East Los Angeles to the Pacific Ocean, or vice versa, Sunset Boulevard wends its way through a kaleidoscope of the city's disparate economic levels and increasingly multicultural demographics. If one takes into account its name change east of Olvera Street (changed first to Brooklyn Avenue and more recently to Cesar Chavez Boulevard), the renowned thoroughfare takes one from heavily Latino (once heavily Jewish) Boyle Heights; past the central Plaza and Chinatown; through hipster Echo Park, Silver Lake, East Hollywood and Hollywood; along West Hollywood's glamorous Sunset Strip; into the tony Westside of Beverly Hills, Holmby Hills, Bel Air, Westwood, Brentwood and Pacific Palisades; and finally coming to a halt—or a new beginning—at the Pacific Coast Highway. For newcomers and longtime Angelinos alike, taking the Sunset Boulevard tour, with sidebar excursions along the way, is a must.

8

Colonel William Selig: Hollywood's Forgotten Man

He was the first filmmaker to take advantage of the endless possibilities of making movies in Southern California, with its year-round mild climate and wide-ranging topography. He produced the first American horror film (*Dr. Jekyll and Mr. Hyde*, 1908) and first feature-length film made in the United States (*The Coming of Columbus*, 1912), shot the first films in the American West with authentic cowboys and Native Americans, originated the "cliffhanger" and jungle-adventure movie genres, opened the first permanent movie studio in Los Angeles and—decades before Disneyland and Universal Studios—planned a combination movie studio and theme park. And yet William Selig's seminal contributions have been all but forgotten. The neglect may lie partly in his generosity in helping others succeed rather than emphasizing his own accomplishments, but mostly it stems from his pioneering Selig Polyscope Film Company's folding in 1918, just as Hollywood was bounding over the once-dominant French and Italian film industries to become the world's movie capital.[61]

Selig was born in Chicago in 1864, the youngest of five children of a shoemaker, Joseph Franz Selig, and his wife, Antonia. He quit school in his teens, worked briefly in an upholstery shop, became the apprentice to a magician and, while still in his teens, began touring the Midwest as a vaudeville performer with his own minstrel show. Like Herman Silver and others with ailing lungs, he moved West for the climate. Settling first in San Francisco and touring the state as "Selig the Conjurer," he had upped his ownership to two minstrel companies by 1893. Although never having

Colonel William N. Selig, circa 1914. *Courtesy of the Academy of Motion Pictures Arts and Sciences.*

served in the military, Selig adopted the title of "Colonel," an affectation of respect common for the times, but in his case, belied by his Falstaffian stoutness, a thick mustache and a jovial disposition.[62]

A two-week engagement at the Texas State Fair in 1894 dramatically altered the course of his life and of cinema history in general. Employees from Thomas Edison's laboratory were demonstrating a so-called kinetescope: a jukebox-like contraption for viewing a short, live-action filmstrip through a peephole. Selig was amazed by the magic box. He was equally impressed by the commercial success the device would prove when it began appearing in penny arcades across the country the same year.[63]

Although the kinetescope, and later kinetephone (a kinetescope linked to a music-playing phonograph), was the first viable motion picture viewing system, it fell to European inventor/entrepreneurs to create "the movies" by projecting films on a big screen to paid audiences in a theater. The first such showings took place in Berlin and Paris in late 1895 and in London in early 1896. The first United States exhibition, under Edison's banner, premiered at New York's Koster and Bial's Music Hall on April 23, 1896.

Selig wasn't far behind. With the help of machinist Andrew Schutsek, he began producing a variation on the cinématographe, the state-of-the-art French camera-printer-projector developed by the Lumière brothers.[64] By late 1896, the newly formed Selig Polyscope Film Company, headquartered in Chicago, was not only producing film equipment but motion pictures as well. By 1908, it had grown large enough to join the Motion Pictures Patents Company (MPPC), an early cartel of the biggest American movie companies and branches of leading French firms. Consisting of other now-defunct companies such as Edison, Biograph, Vitagraph, Kalem, Lubin, Essanay and Star Films, the MPPC was designed to protect its major studios from the competition of upstarts. Of course, the strategy backfired, as the upstarts—with names such as Universal, Paramount, Fox and, later, Columbia, MGM and Warner Brothers—eventually leapfrogged the cartel to become the new majors.[65]

For a time, however, Selig Polyscope held its own. The company produced the first narrative film shot in Los Angeles, *The Count of Monte Cristo*, in 1908 and in 1909 presaged the industry's westward migration by briefly establishing, in a converted downtown laundry, the first actual Los Angeles film studio. Later the same year, the company moved to a more spacious and permanent facility at 1800 Glendale Boulevard in Edendale. This still comparatively isolated area with its hills, valleys, mountain backdrops, quiet residential streets and bodies of water, all within striking distance of bustling

Portrait of "Colonel" William N. Selig, circa 1923. *Courtesy of the Academy of Motion Pictures Arts and Sciences.*

downtown, proved an ideal site for making movies and building studios—so ideal that a slew of them sprang up in Edendale in the early 1910s, some of which, under different ownership, remain in operation today.

Mack Sennett's first Keystone Film Company studio (now a storage facility) became Selig's neighbor at 1712 Glendale Boulevard. A second Sennett studio in Silver Lake, intended for star Mabel Normand (and once again in operation today), was built at 1215 Bates Avenue (more on these two studios in the next chapter). Cowboy star Tom Mix's Mixville studio (since replaced by other structures), was initially affiliated with Selig Polyscope and located nearby, at the corner of Silver Lake and Glendale Boulevards (more on Mixville in chapter eleven). Three other MPPC companies set up shop in the area. Kalem and Essanay resettled along Sunset Boulevard near Fountain Avenue in facilities later taken over by mini-major Monogram, more recently by KCET television and now owned by Scientology. Vitagraph built the Prospect Studios at Prospect Avenue and Talmadge Street, which later housed Warner Brothers and is now owned by Disney/ABC.[66] Indeed, given the preponderance of film factories and myriad films shot in the area in the movies' early days, Edendale can rightly claim to predate Hollywood as Los Angeles's first film production center, with Cololnel William Selig as its founding father.

During his years in Edendale, Selig's company produced and/or distributed nearly one thousand films, introduced the world to Tom Mix and Roscoe "Fatty" Arbuckle, initiated the "cliffhanger" in movies with *The Adventures of Kathlyn* (1913) and *The Spoilers* (1914) and launched, for better or worse, the jungle adventure film. The latter coup occurred by coincidence. After having been rebuffed by Teddy Roosevelt as a tag-along on his highly publicized African safari in 1908, Selig produced a "fake" safari featuring an actor doubling as the former president. The faux documentary, *Hunting Big Game in Africa*, was a huge hit, much greater than the "official" documentary of the president's trip, *Roosevelt in Africa*.[67]

The jungle film's success eventually prompted Selig to open his own thirty-two-acre zoo in 1913. For the enterprising businessman, the exotic animals housed in the Lincoln Park section of East Los Angeles served a dual purpose: as main attractions for the zoo and as star players in his jungle films. In 1916, Selig sold his Glendale Boulevard studio to William Fox of Fox Films and moved his entire film operation to the Lincoln Park site (the Glendale Boulevard studio was replaced by a nondescript commercial/residential building in 1923). Selig's plans for the zoo went beyond its doubling as a studio and talent pool. Trumping Disneyland by forty years and Universal

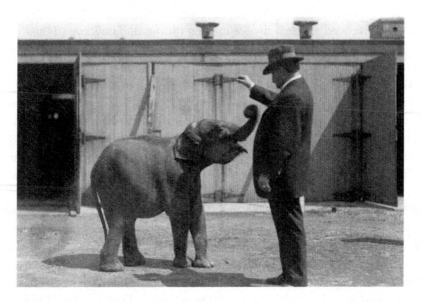

Colonel William N. Selig with a baby elephant, circa 1913. *Courtesy of the Academy of Motion Pictures Arts and Sciences.*

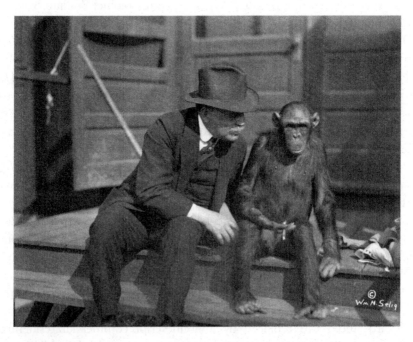

Colonel William N. Selig with a chimp from Selig Zoo, circa 1913. *Courtesy of the Academy of Motion Pictures Arts and Sciences.*

Studios Tour by half a century, he envisioned expanding the zoo and film studio into an amusement park replete with rides, theaters, restaurants and a hotel.[68]

Alas, "Selig Land" got only as far as a single carousel. Its film fortunes sagging, Selig Polyscope ceased production in 1918. Selig continued to produce films independently (mainly jungle-adventure shorts) until 1938, and the zoo remained open through the mid-1930s, finally succumbing to the Great Depression. The year before his death in 1948, he was awarded an honorary Academy Award for his special role in the history of the motion picture industry. A star on the Hollywood Walk of Fame, at 6116 Hollywood Boulevard, was embedded posthumously. His ashes are enshrined at the Chapel of the Pines Crematory in the West Adams neighborhood of Los Angeles.

9

Mack Sennett, Mabel Normand and the Fun Factory

Although they never tied the knot, Mack Sennett and his "star of stars," Mabel Normand, were Hollywood royalty in the heyday of the silent-film era. Sennett was dubbed the "King of Comedy" for his seminal role in developing the slapstick comedy and turning it into one of the most popular film genres and, perhaps most of all, for discovering and nurturing a who's who of film comics. Besides the Keystone Kops, these included Charlie Chaplin, Roscoe "Fatty" Arbuckle, Andy Clyde, Ben Turpin, Harry Langdon, Chester Conklin, Marie Dressler, Louise Fazenda, W.C. Fields, Raymond Griffith, Harold Lloyd, Polly Moran, Ford Sterling and, of course, Mabel Normand.[69] With more than one thousand film credits, Sennett is also one of the most prolific producer/director/writer/actors of all time.

Normand was no slouch. She starred in an estimated 137 film shorts and 23 features, contributed to Sennett's talent discoveries and became one of the first female directors and screenwriters. Tragically, she also suffered from substance abuse, became embroiled in a major scandal that crippled her career and died at the age of thirty-seven from the complications of tuberculosis. Together and apart, professionally and romantically, in their ups and downs, Sennett and Normand encapsulated the movie business in its formative years—much of which, as the previous chapter showed, was centered in the erstwhile peaceful farming community of Edendale.

Mikall Sennett was born in 1880 to Canadian-born parents of Irish ancestry in Danville, Quebec, a mining town about seventy miles north of the Vermont border. While he was still a teenager, the family moved

to East Berlin, Connecticut, where his father worked in construction and Sennett himself got a job at a local iron foundry. Blessed with a fine baritone singing voice, Sennett's early ambition was to perform classical opera. But when the family moved to Northampton, Massachusetts, a chain of events led him instead to the stage and, ultimately, to the fledgling film industry. In Northampton, Sennett met the city's mayor (and future United States president) Calvin Coolidge, who introduced him to theater (and later silent-screen) star Marie Dressler, who in turn introduced him to legendary New York impresario David Belasco.[70]

Although his stage career proved undistinguished, his singing voice led, in 1907, to a position in New York's historic Riverside Church choir. Sennett soon formed his own men's quartet, the Happy Gondoliers, whose city tours brought him in contact with D.W. Griffith, then chief director of the Biograph company. Sennett quickly moved up the Biograph ladder, from bit parts to writing a script to playing the lead in *Father Gets in the Game*s (1908) and finally to the opportunity to make films of his own in the emerging movie mecca of Los Angeles.[71]

Following hard on William Selig's heels, Griffith came to Los Angeles with Biograph in 1909 and, the following year, made the aforementioned first film version of *Ramona*, as well as the first film shot in Hollywood proper, *In Old California*. Sennett, meanwhile, made his directorial debut for Biograph in 1911 with the comedy short *Comrades*, in which he also co-starred, and followed it up that same year with another comedy, *The Diving Girl*. Besides establishing his comedy chops, the films encouraged Griffith (who still worked on both coasts) to send Sennett and his leading lady in *The Diving Girl*, Mabel Normand, to Los Angeles in 1912 to establish a West Coast branch of Biograph. Instead, with financing from Adam Kessel and Charles Bauman's New York Picture Company, Sennett started his own Keystone Film Company, which almost overnight thrust both him and Normand to the top of the Hollywood heap.[72]

Normand was born in 1892 on Staten Island. Her destiny as an actress seems to have been forged by her ancestry. Her grandmother on her father's side, Adrienne Marie Beraud, had been a stage actress in France before moving to Quebec and, later, to Providence, Rhode Island, where her son Claude grew up in local theaters and later played piano to supplement the family income. From her father, Normand inherited a love for art, music and romance, as well as an inclination to the reckless behavior and depression that would eventually cut short her career and her life. To her mother, she attributed the poor judgment that contributed to her demise

Mack Sennett, the King of Comedy. *Courtesy of the author.*

Opposite, top: Keystone Studios, 1917. *Courtesy of the Watson Family Photo Archive.*

Opposite, bottom: Keystone Kops on patrol. *Courtesy of the Watson Family Photo Archive.*

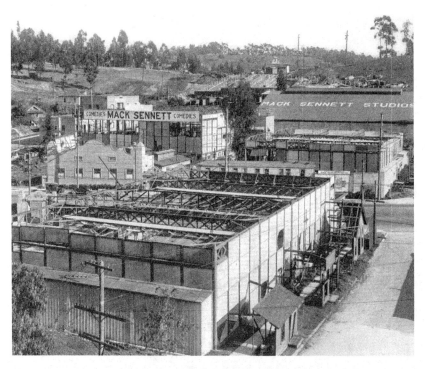

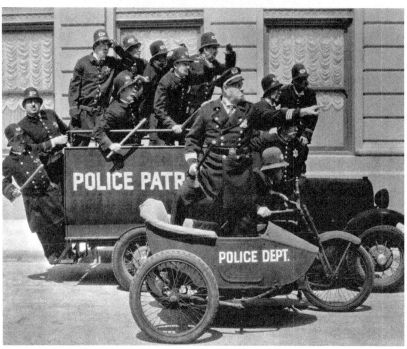

Left: A Mabel Normand portrait.

Below: Roscoe Arbuckle and Mabel Normand in *Mabel Adrift* (1916).

but also the boundless energy and a strong determination that would propel her quick rise to stardom.[73]

In 1908, the ambitious Normand moved to Manhattan, then still the entertainment hub of the country. At sixteen, she was already a vivacious beauty with a slim curvaceous figure, large expressive eyes and a mass of jet-black curly hair. She quickly made her mark. After a stint as a Gibson girl model, in 1910 she joined Griffith's Biograph acting troupe, where she met Sennett. Working with him at Biograph and later at Keystone, Normand developed into more than a highly gifted comedienne. Foreshadowing the Jazz Age flapper girls and Clara Bow's "It Girl," Normand was the original "I Don't Care Girl." She flaunted her beauty in a spirit of playful misbehavior that stood in stark contrast to the era's still prevalent, if rapidly fading, Victorian mores.[74]

Normand's *The Diving Girl* role predicted another of Sennett's trademarks: showing young women in provocative bathing suits at a time when "knees were a treat and ankles were an orgy."[75] Although Normand remained a cut above Sennett's so-called Bathing Beauties, several of these, who started out anonymously, would become stars in their own right, including Phyllis Haver, Marie Prevost, Carole Lombard and Gloria Swanson.

While Sennett is rightly credited with discovering many great talents, Normand played a crucial role in their development as well, most famously with Charlie Chaplin and Roscoe Arbuckle, both of whom Sennett was ready to give up on but for her intervention. Her own screen persona extended beyond her "I Don't Care Girl" sexuality. Belying her dainty appearance, she possessed considerable athletic skill, performed many of her own stunts and was capable of playing anything from daredevil to clown. By 1915, Sennett affirmed Normand's superstar status by building for her a still standing (and again operating) studio on Bates Avenue in Silver Lake—its triangle shape clearly a nod to Harry and Roy Aitken's Triangle Film Corporation, which Sennett had joined in 1915 with the era's other two filmmaking giants, D.W. Griffith and Thomas Ince.

The gift was also compensation for one of Sennett's own weaknesses: womanizing. The night before their planned wedding on the Fourth of July 1915, Sennett was caught in bed with one of Normand's acting rivals, Mae Busch. The damage, this time, was too great to repair. Sennett and Normand made only one film together at her new studio, their first feature-length comedy, *Mickey*, which, though a hit, could not mend their long-turbulent, now tattered, romantic and working relationship.[76] In 1917, Sennett formed a new company, Mack Sennett Comedies, from which the Bathing Beauties

Mack Sennett's "Bathing Beauties," 1919.

Mack Sennett Studios, 2014. *Photo by Michael Locke.*

would stem. In 1918, Normand signed with Samuel Goldwyn, where she received a boost in salary and total control of her pictures.

Just as her professional life reached its peak, however, Normand's personal life began to unravel. Like many celebrities, past and present, who rocketed to stardom at an early age, she was unable to deal with the fame and accoutrements of success. The one-time tomboy who thumbed her nose at upper-class snobbery—preferring to flirt with boys, smoke cigarettes, chug whiskey and snort cocaine—would become the victim of her own excess. At a time when movie star scandals were becoming all the rage, for better and worse, Normand became linked to two of them.

The biggest scandal involved megastar Roscoe "Fatty" Arbuckle. Arbuckle's alleged rape and killing of starlet Virginia Rappe at a Prohibition-defying party in 1921 (to be detailed in the next chapter) moved the Hollywood moguls to form a new public relations agency, the Motion Picture Producers and Distributors of America (MPPDA), to counter the industry's increasingly tarnished image. To blunt the anti-Semitic thrust of much of the criticism, the predominantly Jewish studio heads hired Presbyterian deacon and former postmaster general Will Hays to lead the agency.[77] Hays's first act was to ban Arbuckle, despite his acquittal on all charges, from the screen for life. However, just as the Hays Office (as it came to be known) was striving to clean up Hollywood's act, the William Desmond Taylor murder in 1922, implicating Mabel Normand, tossed it back into the gutter.

The night that Taylor was killed, Normand had visited the noted film director at his apartment in the then-fashionable Westlake Park area. Apparently only close friends with Normand, the possibly gay director had been expanding Normand's cultural horizons and, some sources say, was in the process of helping her file charges against her cocaine suppliers, who then put out a contract on him. In the end, neither Mabel nor the other usual suspects—starlet Mary Miles Minter, Minter's mother and Taylor's butler Henry Peavey—were charged in the case, which, like many Hollywood crimes (some would say suspiciously), has never been solved.[78]

If Taylor's death and the scandal surrounding it started Normand's downward career and life spiral, another scandal three years later sent it careening. On New Year's Day 1924, Normand's chauffer Joe Kelly shot and seriously wounded oilman Courtland Dines with a gun belonging to Normand. One possible motivation for the shooting, fueled by the yellow press, was that Kelly was infatuated with Normand and shot Dines out of jealousy. At the trial, Dines refused to testify, and Kelly was acquitted. For Normand, however, as with Arbuckle, her off-screen image as a possible murderess and

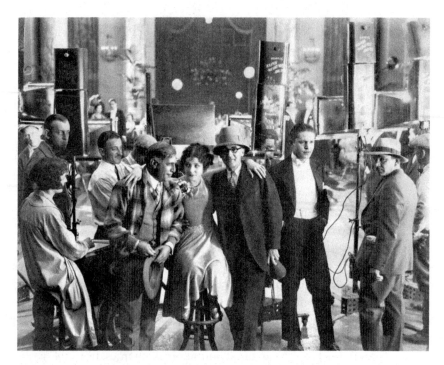

Mack Sennett (in the checkered coat) visiting the set of *The Gay Deceiver* (1926).

Mack Sennett Studios, 2014. *Photo by Michael Locke.*

dope fiend clashed with her on-screen image as a rambunctious but good-hearted "girl next door." Nor did Normand's impulsive marriage in 1926 to actor Lew Cody serve as damage control, career- or health-wise. The couple lived separately throughout their marriage as the effects of her tuberculosis became increasingly debilitating.[79] Normand died on May 8, 1930, after an extended stay at Pottenger Sanitarium in Monrovia, California.[80]

Sennett's post-Normand life and career were more propitious. Although the coming of sound in the late 1920s spelled the end of his brand of knockabout comedy, he made a fairly smooth transition into the new era with his first talkie short, *The Lion's Roar*, released in 1928. In 1932, he received an Academy Award nomination in the comedy short category with *The Loud Mouth* and won the Oscar in the novelty division for *Wrestling Swordfish*. Two successful comedies the same year starring Bing Crosby resulted in a brief relationship with Paramount Pictures, with whom he would produce seventeen comedies through 1933, four starring W.C. Fields. They would be his last.

Retired but not forgotten, Sennett in 1938 was again honored by the academy. This time "that master of fun, discoverer of stars, sympathetic, kindly, understanding comedy genius" was given a special Honorary Academy Award "for his lasting contribution to the comedy technique of the screen, the basic principles of which are as important today as when they were first put into practice."[81]

Sennett died on November 5, 1960, in Woodland Hills, California, at the age of eighty. His remains are interred at the Holy Cross Cemetery in Culver City, California. When he died, he willed his estate to the Los Angeles Orphan Asylum and the Jewish Orphans Home, not knowing he had nothing left to will.[82] His first Edendale studio site (now a storage facility) has been designated a Historical Cultural Landmark, and both his and Mabel Normand's ghosts hover over the former Mabel Normand Feature Film Company. The studio where the duo's first feature-length comedy, *Mickey*, was shot has experienced a remarkable rebirth as the Mack Sennett Studios, in the same building and at the original location, 1215 Bates Avenue. Besides professional film shoots, screenings and fundraisers, personal tours and community events are also available at the historic Silver Lake site.

THE SAD SAGA OF
ROSCOE ARBUCKLE

Although Roscoe "Fatty" Arbuckle isn't forgotten, as William Selig largely has been, he is best remembered for the worst of reasons. In 1914, after just five years in the business, Arbuckle reigned as the king of film comics and the highest paid star in Hollywood, having just signed with Paramount, where he also was granted unprecedented artistic control and 25 percent of profits. Seven years later, at the zenith of his popularity and with a new three-year, $3 million contract (over $40 million by today's standards) with Paramount under his belt, he was laid low by what was then deemed the scandal (and later trial) of the century.[83]

In retrospect, signs of Arbuckle's future troubles were evident from birth. As much as he came to despise his childhood and movie nickname, he was fated to be called "Fatty" when he came into the world in 1887, weighing over thirteen pounds (some sources say sixteen pounds). His abusive, alcoholic, smallish father, not believing the boy was his, named him after a public figure he despised: philandering New York Republican senator Roscoe Conkling. The difficult birth, having contributed to his mother's ill health (and death twelve years later), would cast further blame on the boy, making it perhaps a blessing when his father abandoned the family shortly after they moved from Kansas to Santa Ana in 1889.[84]

These traumatic circumstances, combined with the family's poverty and isolation, and his own outsized bulk, turned Arbuckle into a painfully shy, socially awkward young man. The awkwardness did not extend to a grace and agility that belied his size and girth, however, and a wonderful tenor singing voice that would briefly banish the shyness.

Through a series of serendipitous events, Arbuckle's talents caught the attention of theater mogul Sid Grauman (of Grauman's Chinese Theater fame), who hired Arbuckle to sing at his Unique Theater in San Francisco in 1904. From there, he joined a succession of touring vaudeville companies as a headliner, at one point allegedly so impressing Enrico Caruso that he advised Arbuckle to give up his slapstick "nonsense" and begin concentrating on becoming "the *second* greatest singer in the world."[85]

In 1908, while both were performing in Long Beach, Arbuckle met actress Minta Durfee, whom he would marry the same year and who would later appear in his early films. His film career began in Edendale in 1909, first with Selig Polyscope, where he made a series of one-reelers (ten- to fifteen-minute films, the then-standard length for comedies). After a brief stint at Universal, he moved to Mack Sennett's Keystone company, where by 1914, with Mabel Normand's aid, he blossomed into a full-blown star. Sennett had been on the verge of giving up on the baby-faced fat man, but Normand coaxed Sennett into recognizing the comical potential of their pairing, with Normand's spunky daintiness providing a fitting foil for Arbuckle's incongruously large size and acrobatic ability. "He skipped up the stairs as lightly as Fred Astaire," Sennett later recalled, "and did a backward summersault as graceful as a tumbler."[86]

By 1918, after his new deal with Paramount, Arbuckle's popularity as a film comedian was rivaled only by Charlie Chaplin. The creator of the iconic Tramp character had been involved in his own scandals in the late 1910s, given Chaplin's attraction to teenage girls and marriage (in Mexico) to two of them. While Chaplin managed to survive the gossip mongering, his career scaling new heights in the 1920s and '30s, Arbuckle's penchant for the Hollywood high life got the better of him.

On September 5, 1921, Arbuckle and film friends Lowell Sherman and Fred Fischbach drove to San Francisco for the Labor Day weekend. More "fun-loving" than the comparatively staid Los Angeles, San Francisco had become the playground of choice for many stars during the early Prohibition period. Along with the booze and drugs at Arbuckle and company's Saint Francis Hotel bash came a bevy of young girls, among them an aspiring starlet, Virginia Rappe, with a racy reputation and a chronic bladder condition. Well into the multi-day party, Rappe was found unconscious in Arbuckle's room. Delayed in her hospitalization to keep the matter hush-hush, she died four days later of peritonitis from a ruptured bladder.[87]

Though the tragedy clearly resulted from the exacerbation of Rappe's previous condition from the overindulgence in booze and drugs, an ambitious

Roscoe Arbuckle with an unidentified female actor. *Courtesy of the Watson Family Photo Archive.*

Opposite, top: The Lasky studios where Houdini was making *The Grim Game* and Roscoe Arbuckle was making *Back Stage*, 1919.

Opposite, bottom: Roscoe Arbuckle, before his first trial, leaning against his 1919 custom-built Pierce Arrow Model 66A Tourer. *Courtesy of the author.*

district attorney wasted no time in recklessly charging Arbuckle with taking advantage of the intoxicated young woman and raping her to death with a liquor bottle. The yellow press, of course, had a field day with the wild accusations, which irreparably destroyed Arbuckle's childlike screen image before his acquittal on all charges at the third of his "trials of the century" (the first two having ended inconclusively, likely due to juror bribery). Taking less than five minutes to reach a verdict, the third jury added a statement:

ROSCOE C. ARBUCKLE
THE
KEYSTONE FAT BOY

Opposite: Roscoe Arbuckle at his second trial. *Courtesy of the Watson Family Photo Archive.*

Left: A Roscoe Arbuckle portrait. *Courtesy of the Gallery of Popular Players,* Motion Picture Magazine, *May 1914.*

Below: Roscoe Arbuckle's former Silver Lake home at 1383 Lucile Avenue, as seen in 2014. *Photo by Michael Locke.*

"Acquittal is not enough for Roscoe Arbuckle. We feel also that it was only our plain duty to give him this exoneration, under the evidence, for there was not the slightest proof adduced to connect him in any way with the commission of the crime."[88]

Despite the hefty legal fees that all but broke him financially and the shattering of his screen persona, Arbuckle may have been able to resuscitate his career after a reasonable cooling-off period. Coming at a time, however, when Hollywood had become vulnerable due to the spate of movie-star scandals and film content judged overly risqué by the puritanical standards of the day, Arbuckle became the industry's sacrificial lamb. As mentioned in the previous chapter, Will Hays tossed Arbuckle to the wolves in 1922 as his first act as head of the newly founded Motion Picture Producers and Distributors of America (today the Motion Picture Association of America, MPAA).

Initially banned from the screen for life, Arbuckle was forced to revert to stage and nightclub appearances and occasional film-directing jobs under the sardonic pseudonym Will B. Good. The bitterest irony occurred in 1933, when, with the ban finally lifted and Arbuckle on the verge of a sound-era comeback in a series of shorts featuring his melodious voice for the first time, he died in his sleep shortly before the first film's release. He was forty-six years old.

Although the cause of death was listed as a heart attack, his old buddy Buster Keaton, whom Arbuckle had given his break in the business, said that the actual cause was a broken heart. And despite the decade-long hiatus from the screen, thousands of fans lined the streets outside Campbell's Funeral Home at Sixty-sixth Street and Broadway, where his body lay in state in the Gold Room, the same room where Rudolph Valentino's had lain seven years earlier. After the funeral, Arbuckle's body was sent to New York, where it was cremated at Fresh Pond Cemetery.[89]

Besides the Selig Polyscope and Keystone connections to Edendale, Arbuckle had resided during his early film days at 1383 Lucile Avenue in the Child Heights subdivision of Silver Lake. In 1919, he took up residence at the home of Tulita Wilcox Miner in the fashionable West Adams district near the corner of Figueroa Boulevard. The mansion still stands, a few blocks from the University of Southern California and abutting the campus of Mount Saint Mary's College. His star at the Hollywood Walk of Fame is located at 6701 Hollywood Boulevard.[90]

TOM MIX: KING OF THE COWBOYS

If Mack Sennett, Mabel Normand and Roscoe Arbuckle embodied, on-screen and off, America's rough-and-tumble entry into the modern age, Tom Mix personified an Old West that, when he rose to movie fame in the early 1900s, still partly existed. Not the first of the cowboy stars, this distinction belonging to an Arkansas Jew renamed and repurposed as "Bronco" Billy Anderson (né Max Aronson), Mix (his real name) was a real cowboy and the quintessential western hero whose moral code, sharp shooting and athleticism rescued damsels in distress and set the frontier aright. Between 1909 and 1935, Mix appeared in 291, mostly silent, films. Although he would be usurped in the sound era by singing cowboys Tex Ritter, Gene Autry and Roy Rogers, Mix, along with Anderson and William S. Hart (another non-cowboy cowboy), defined the essential traits of the oater genre for all the white hats (and occasional black ones) to come.[91]

Mix was born in 1880 in Mix Run, Pennsylvania, a tiny hamlet named after his great-grandfather Amos Mix, of English-Irish descent and one of the area's first settlers. Like many of his forebears, Mix's father was a rugged lumberman and also a skilled horseman, an avocation his son avidly followed. When Buffalo Bill and his Wild West show came to town when he was about ten, Mix's dream of becoming a cowboy performer was fired in earnest. Its realization would be put on hold—first by the Spanish-American War, in which he dutifully served, and next by a postwar reenlistment, from which he reportedly deserted. Settling in the Oklahoma Territory in 1902, he became drum major with the Oklahoma Calvary Band, whose invitation

to perform at the 1904 World's Fair in Saint Louis proved to be the turning point in his life.[92]

At the fair, he met the not-yet-world-renowned Will Rogers, playing a rodeo clown in a Wild West show. Besides the two becoming lifelong friends, the experience rekindled Mix's cowboy performer dreams. After a stint with a cowboy brigade that performed at the inauguration of "Rough Rider" President Teddy Roosevelt in 1905, he finally became a full-time "working cowboy" at the famous Miller Brother's 101 Wild West Ranch, which provided "authentic" western experiences for East Coast vacationers. During this period, Mix married the second of his five wives, Olive Stokes, and gained a daughter, Ruth Mix, who would have B-film acting success in the 1930s.[93]

The Wild West ranch was a proving ground for many western film stars of the era, including Tex Cooper, Ken Maynard and Will Rogers. Mix worked at the ranch through 1909, briefly formed his own operation and then joined the Will A. Dickey Circle D Wild West Show, which contracted with Selig Polyscope. Seeing potential in Mix's rugged good looks, easygoing charm and well-honed horse-riding skill, the company cast him in the short *The Cowboy Millionaire* in 1909 and as the lead in his next film, *Ranch Life in the Great Southwest*. Released in 1910 and shot at Selig's new studio in Edendale, the film was a huge hit and catapulted Mix into the newly minted category, begun with actress Florence Lawrence the same year, of motion picture star.[94]

When Selig moved all his operations from Chicago to Edendale in 1913, Mix became a partner in the company and built his own studio, the aforementioned Mixville, just up the street from Selig Polyscope on Glendale Boulevard in Silver Lake. Mix appeared in over one hundred films for Selig. He also became romantically involved with and eventually wed one of his co-stars, Victoria Forde. After William Fox took over Selig's studio in 1918, Mix's films appeared under the Fox banner into the 1920s, during which time his popularity surpassed that of the first "king of the cowboys," William S. Hart.[95]

At the apex of his fame in 1922, Mix and Forde had a daughter, Thomasina, and settled in a rented bungalow at 1610 Golden Gate Avenue in Silver Lake. On the Mixville lot, the cowboy mogul built a mock western town, replete with dusty streets, a saloon, a jail, a bank, a hotel and simple frame houses typical of the frontier, surrounded by a simulated desert dotted with Indian tepees and ringed by majestic mountains made of plaster.[96] Although two real banks, a liquor store and a large shopping center have since replaced Mixville's faux Wild West set, a modern condominium complex across the

Tom Mix aboard the SS *Aquitania*, bound for Europe, 1925. *Courtesy of the Research Division of the Oklahoma Historical Society.*

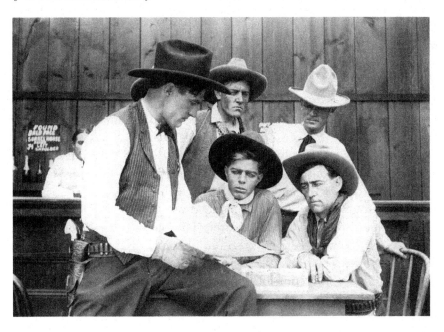

Tom Mix (far left) in an unidentified Western. *Courtesy of the Research Division of the Oklahoma Historical Society.*

Tom Mix sharing the good life with his fourth wife, Victoria Forde, presumably at Santa Anita Race Track. *Courtesy of the Research Division of the Oklahoma Historical Society.*

Opposite, top: Tom Mix on his horse Tony, being mobbed at London's Rotten Row, April 16, 1925. *Courtesy of the Sport and General Press Agency, London; Research Division of the Oklahoma Historical Society.*

Opposite, bottom: Tom Mix's former residence in Silver Lake. *Photo by Michael Locke.*

street at least acknowledges some of the area's real and imagined past in its name: Mix Lofts.

Mix made his last film for Fox in 1928, after which the studio decided not to renew his contract. He made six more silent films for the Film Booking Office in 1928 and 1929, all of which were flops. Nor, at forty-eight years old and with a voice judged as "not recording well," did his subsequent films fare much better. The blow to his superstar ego, however, was nothing compared to the financial disaster he suffered in the stock market crash of 1929, through which he lost his new Beverly Hills mansion, a stock portfolio in excess of $1 million and a "dream ranch" in Arizona.[97]

It all came to an end on October 12, 1940, along a lonely highway eighteen miles from Florence, Arizona. Mix was scheduled for an appearance in Tucson, when his custom-built Cord roadster swerved to avoid a crew of highway

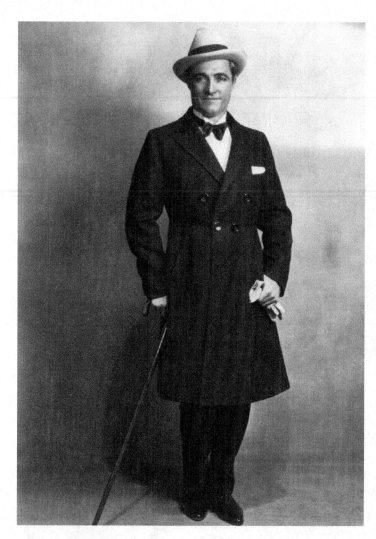

Tom Mix could have been on America's Best-Dressed Man List in this attire. *Courtesy of the Research Division of the Oklahoma Historical Society.*

workers, slid down a dry wash and overturned, leaving him pinned beneath the wreckage. Eyewitnesses claimed that he died "with his boots on," wearing his familiar white, ten-gallon Stetson and diamond-studded belt. A monument was erected at the crash site: a rider-less pony mounted on a granite column and a plaque with the inscription, "In memory of Tom Mix whose spirit left his body on this spot and whose characterizations and portrayals in life served to better fix memories of the old west in the minds of living men."[98]

AN IMMIGRANT ARCHITECT
BUILDS HIS DREAM HOME

S ilver Lake not only played a seminal, if inadequately credited, role in the development of the film industry, but it was also, and remains, home to some of the most spectacular, and significant, architecture of the twentieth century. Among the more neglected of its iconic designers—albeit in the more romantic than modernist vein that has garnered the most attention—is Armand Monaco (1895–1981). Monaco, whose name couldn't be better suited to the grandiosity of many of his projects, designed one of Silver Lake's most elegant villas and other lavish homes for wealthy clients and celebrities, as well as commercial projects, public housing and churches. Also, unfortunately, as Los Angeles's and Hollywood's shadow side seemingly went with the territory, Monaco's extended family would be touched by tragedy and an early Hollywood scandal.

Armand Monaco was twelve when his Italian parents joined the massive turn-of-the-century immigrant wave to the United States from southern and eastern Europe, eventually settling with their five children in Chicago. After graduating from Northwestern University, Monaco served as principal designer in the Chicago architecture firm of Jarvis Hunt. His name first appears in Los Angeles in 1921, when he worked briefly in the offices of Robert D. Farquhar and Myron Hunt, after which he formed a partnership with William Bordeaux. The new firm designed several opulent Italianate-style residences, including one for actress Betty Blythe in Los Feliz and the Villa Monaco in Silver Lake, which Monaco designed for himself; his wife, Carlotta; and their two sons, Renaldo and Rodolfo Raymond.[99]

Villa Monaco at 3021 Waverly Drive in Silver Lake (Armand Monaco and William Bordeaux, architects, 1921) as seen in 2012. *Photo by Michael Locke.*

Seeking more creative self-expression, Monaco branched out on his own in 1927, designing the original French Hospital (now the Pacific Alliance Medical Center) in Chinatown (formerly Little Italy) and in 1928 built a Spanish Colonial Revival–style beach house in Palos Verdes for men's clothing magnate John Joseph Haggarty. Although Monaco's rising reputation preceded him, his choice for the assignment certainly wasn't harmed by the engagement of Haggarty's daughter to one of Monaco's brothers, Salvatore, a Los Angeles physician. The Haggarty-Monaco marriage ultimately fared better than the beach house. The elder Haggarty, preferring city life, spent most of his time in his West Adams mansion, the Castle York (also known as Haggarty Castle), allowing the beach house to fall into disrepair. The Palos Verdes estate, at 415 Paseo Del Mar, eventually passed through several owners before being purchased in 1953 by the United Church of Christ and becoming, as it's known today, the Neighborhood Church.

It wasn't all high-end building for Monaco. In 1937, he was among a select group of socially conscious architects hired by the Los Angeles Housing Authority to design the William Mead Public Housing Project near Union Station in an area then referred to as Dogtown, due to its proximity

to the Ann Street Animal Shelter. The project was the eighth in a series of garden apartments built as part of a government program to offer more humane shelter and a better quality of life to low-income families.[100] Monaco even dabbled in modernist design in a building for the Gillette-Severy-Clark Company in Los Angeles (date and whereabouts unknown).[101] Monaco's last project, in 1957, was the Saint Peter's Italian Church at 1030 North Broadway in present-day Chinatown, designed in a Spanish Colonial Revival style.

Monaco resided in his very own Villa Monaco until 1965. It is not surprising that he chose Silver Lake as the place to stay for the bulk of his career. The area's landscape, climate and quality of light have often been likened to the Mediterranean region, with the reservoirs' silvery waters furthering the kinship. Villa Monaco's Italianate design, meanwhile, reminiscent of the grand palaces of Europe a young Armand might have viewed, would have had more than nostalgic appeal to the transplanted architect. Whether passersby recognized the villa's genealogy, it must have been a stunning sight when it still stood out from its surroundings and before the adjacent 5 Freeway created an especially jarring culture clash.

The freeway would prove more than just an eyesore for the Monaco family, however. In 1967, Armand and Carlotta's son Renaldo, his pregnant wife and another of their children were killed in one of Los Angeles's signature hazards—a head-on collision on the 5. Compared to this horrible tragedy, the Hollywood scandal that befell the family was a minor inconvenience. It was however, dripping with irony. Affecting Armand's brother Rodolfo, the scandal was tied to another "Rodolfo"—legendary matinee idol Rudolph Valentino.

Having achieved near god-like status among his myriad international fans, Valentino's Cathedral Mausoleum in Hollywood Cemetery was visited by an estimated 100,000 people the first two years after his death in 1926. One of his most ardent admirers was a fellow Italian immigrant, Angelina Coppola, who reportedly visited Valentino's crypt several times a week with her likewise Italian-immigrant husband, Matthew, after the couple moved from San Diego to a home a few blocks from the cemetery[102] When their baby boy tragically died soon after birth in 1928, the Coppolas named him Rodolfo Valentino Coppola in honor of their film idol. Two years later, they sued Dr. Rodolfo Monaco, who had been the child's pediatrician, for $75,000 for malpractice.

The circus-like trial featured Angelina Coppola's claims of being warned by Rudolph Valentino's spirit of her baby's endangerment. But the highlight came when a woman burst from the gallery and, claiming to be channeling the spirit of Indian chief Gray Eagle, alleged that Rudolph Valentino's

spirit had sent her to the courtroom to protect Angelina. The judge granted Dr. Rodolfo's counsel's motion for a mistrial. A second trial two years later ended in his full acquittal. Angelina Coppola died in 1956 at age seventy-two and was buried in Hollywood Cemetery. She now lies in a crypt alongside that of her deceased husband, a few steps away from Cathedral Mausoleum.

Whether one is beckoned to Villa Monaco by the ghost of Rudolph Valentino, the palatial estate at 3021 Waverly Drive, with 5,722 square feet of living space, seven bedrooms and five baths on a lot of almost 60,000 square feet, remains one of the grandest Silver Lake homes.

JULIAN ELTINGE:
AMERICA'S FIRST DRAG SUPERSTAR

Long before Georges and Albin came out in the French film *La Cage aux Folles* (1978) or RuPaul made transvestism hip, Julian Eltinge, by the 1910s, had established himself as the greatest female impersonator in the history of American theater. Unlike other gender illusionists of his time, who typically presented themselves as caricatures of femininity, Eltinge presented the illusion of actually being a woman. No one before or since has rivaled his success. However, at a time when homosexuality was far less accepted than today, both socially and legally, his particular brand of fame had its pitfalls. Eltinge overcompensated for presumptions of his gayness by projecting a super-stud image. Publicity photos showed him horseback riding, chopping wood and smoking cigars, and newspapers reported his frequent bar brawls and boxing matches. Predicting the New Journalism antics of George Plimpton, Eltinge went so far as to stage a match with heavyweight boxing champion "Gentleman Jim" Corbett. Eltinge's statement about his suspect sexual orientation nicely captures its ambiguity: "I'm not gay, I just like pearls."[103]

Given the precariousness of the situation, Eltinge, by design, kept the details of his personal life shrouded in mystery and embellished with myth. Born William Dalton in Newton, Massachusetts, in 1881, his parents moved first to California, where his father tried and failed at gold prospecting and then to Montana, where he opened a barbershop. Encouraged by his mother from a young age to dress up in skirts, Eltinge was already performing in drag at local saloons as a teenager. When his father learned of these off-color activities, he beat the boy severely,

causing his mother to send him to Boston for protection in 1899.

Freed from his father's wrath, Eltinge's affinity for dressing up as a woman burst into full bloom. Changing his name to Julian Eltinge, he joined the Cadet Theatricals, a Boston troupe whose all-male members, in classic Shakespearean style, played both male and female roles. Success with the Theatricals propelled him to the Bijou Theater in New York, where in 1904 he played a man disguising himself as a woman in a musical with songs by a young Jerome Kern. Though the show flopped, Eltinge's performance garnered rave reviews and made him a star. He played New York's vaudeville circuit and made a tour of Europe, capped by a command performance for King Edward VII, who presented Eltinge with a pet bulldog.

Julian Eltinge in *Fascinating Widow*, called his greatest stage success.

The "other" Julian Eltinge, as a man. *Courtesy of the Watson Family Photo Archive.*

His solo debut in New York in 1907, in which he parodied the Gibson girl, was a smash hit and catapulted him to the pinnacle of female impersonators. As *Variety* enthused, "The audience was completely deceived as to Eltinge's sex, until he removed his wig...his act is far and away above what is described as female impersonation."[104] Removing his wig to the audience's great amazement became a regular part of his act, always delivered at a high point of the performance for maximum effect.

His biggest stage success came in the musical comedy *The Fascinating Widow*, which, though it had only a short run on Broadway, toured the country for years. In 1911, producer Al Woods affirmed Eltinge's superstar stature by building the Eltinge Theater on Forty-second Street in his honor. Designed by noted architect Thomas Lamb, the theater eventually became a burlesque house, but recently, as part of a new AMC theater complex, the building was moved a short distance and restored, with three portraits of Eltinge, in drag, hanging in the lobby.

Eager to cash in on the burgeoning movie industry, Eltinge moved to Los Angeles in 1917. His first featured role was in *The Countess Charming*, followed by *The Isle of Love* alongside Rudolph Valentino and the soon-to-be-infamous (and tragically deceased) Virginia Rappe. His screen popularity soon earned him the nickname "Mr. Lillian Russell," after the great nineteenth-century stage actress and singer acclaimed for her beauty and style. Not limiting himself to the movies, he launched his own magazine, *Julian Eltinge's Magazine and Beauty Hints*. In 1918, he returned triumphantly to the vaudeville stage with *The Julian Eltinge Players*, performed at New York's Palace Theatre, where he returned the following year in a new review with sets by French designer Erté.

At the height of his multi-media popularity, Eltinge built a lavish estate in the still comparatively undeveloped hills overlooking Silver Lake Reservoir. Dubbed Villa Capistrano, the estate was designed by the renowned architect brothers Francis Pierpont and Walter Swindell Davis, best known as the creators of the courtyard apartment. The choice of Silver Lake for the famed female impersonator's residence was doubly apropos. First, it tapped into the area's film industry roots. Second, it resonated with, and perhaps contributed to, Silver Lake's "Swish Alps" nickname, alluding to the neighborhood's then (and ongoing) sizeable gay and lesbian population. Indeed, Eltinge's still-existing pink villa, at 2327 Fargo Street, sits just across the hill from pioneering gay activist Harry Hay's future home at 2328 Cove Avenue, where the first sustained gay rights organization, the Mattachine Society, was formed in 1950.[105]

With advancing age and mounting public homophobia that turned what was once wholesome family entertainment into "part of a social system that haunted mainstream society," Eltinge's star began to fade.[106]

Left: Julian Eltinge in drag. *Courtesy of the Watson Family Photo Archive.*

Below: Villa Capistrano (Pierpont and Walter Davis, architects, 1918), still standing at 2327 Fargo Street in Silver Lake. *Courtesy of the Watson Family Photo Archives.*

Villa Capistrano, overlooking Silver Lake Reservoir. *Courtesy of the Watson Family Photo Archive.*

The Hays Office's Production Code of the 1930s ruled the words "fairy," "nance" and "pansy" taboo; police began cracking down on public cross-dressing; and Eltinge, all but banned from the screen like Roscoe Arbuckle, was relegated to sporadic night club acts that paid a fraction of his previous worth.[107] Hanging on until 1941, he fell ill while performing at the Diamond Horseshoe night club on May 7, 1941, and died of a cerebral hemorrhage in his Manhattan apartment ten days later. His body was cremated and his ashes sent to his mother, who still lived in Hollywood. His remains are interred at Forest Lawn Memorial Park in Glendale along with those of his parents.

THE CRESTMONT MANSION
PART 1: THE LIFE AND TIMES OF
ANTONIO MORENO

Nowhere do Hollywood, mansion building and sexuality come together more intriguingly than in the exciting, tragic but ultimately redemptive tale of silent screen star Antonio Moreno; his wife, oil heiress Daisy Canfield; and the Crestmont Mansion they built atop the appropriately named Moreno Highlands section of Silver Lake.

Antonio Garrido Monteagudo Moreno was born in Madrid, Spain, in 1887. After his soldier father died when he was still a baby, his mother moved with him to Gibraltar. On the British island, Moreno grew into a handsome lad of impressive charm, impressive enough to attract (in more ways than one?) two important tourists: Benjamin Curtis, son of United States Supreme Court justice Benjamin Robbins Curtis, and Enrique de Cruzat Zanetti (also known as Sheikh Birbal), a leader in the Sufi branch of Islam. Curtis and Zanetti hired the teenager for the remainder of their travels as an interpreter and nurse to the ailing Curtis. Arriving in New York in 1902, Moreno wasted no time in attracting more patrons, including Charlotte Morgan, a wealthy widow who invited him to live with her in Northampton, Massachusetts.[108]

In Northampton, Antonio caught the acting bug after playing in a summer production of the resident stock company. Moving to New York with the cast, he worked (and charmed) his way into the company, made his Broadway debut in 1910 and, by 1912, was doing Shakespeare with the touring Southern and Marlowe Company. When English director Walter Edwin suggested he might do well in motion pictures, Moreno moved to Hollywood in 1912 and appeared in seven films during the year of his arrival.[109]

Antonio Moreno at the Crestmont estate.

In all, Moreno appeared in 140 films between his first, *The Voice of Millions*, and his last, *El Señor Faron y La Cleopatra (Mr. Pharaoh and Cleopatra, 1958)*, a romantic comedy filmed in Cuba but never released in the United States. Rising to fame as an exotic romantic hero and benefitting from the Latin Lover craze started by Rudolph Valentino, Moreno appeared alongside nearly every important dramatic star of the silent era, including Mary Pickford, Blanche Sweet, Lillian and Dorothy Gish, Norma Talmadge, Greta Garbo, Pola Negri, Gloria Swanson and Clara Bow. Replacing Valentino as *Numero Uno* after his Italian rival's untimely death in 1926, he also possessed Elinor Glyn's sexy "It" factor. Not coincidentally, Moreno co-starred with Clara Bow, for whom the term was coined, in the film *It* (1927), her first starring role.

In 1923, Moreno married Daisy Canfield, daughter of oil magnate Charles Canfield, who, with Edward Doheny, had put Los Angeles on the black-gold map with their oil discoveries of the 1890s. Opinions then and

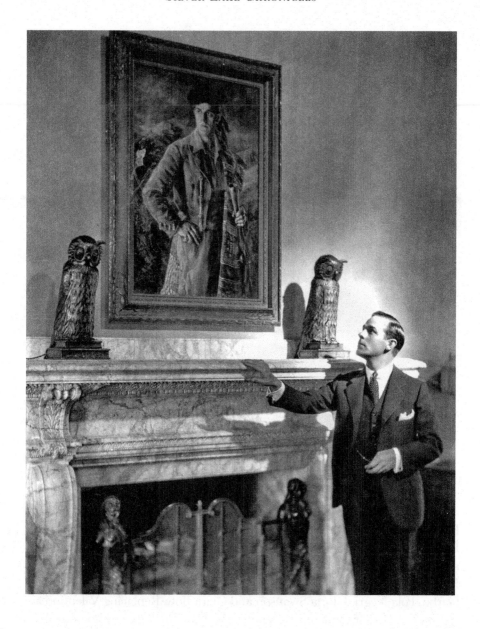

now consider Daisy's marriage to Moreno doubly one of convenience, given possible same-sex inclinations on both their parts (no pun intended). A perception of "normalcy" in sexual relations would have been especially important for a macho-playing (and foreign to boot) movie star like Moreno, as it had been for Valentino, who constantly had to fend off slurs on his manhood.[110]

Opposite: Antonio Moreno peers at a portrait of himself.

Left: Antonio Moreno in a formal portrait.

Below: Antonio Moreno at the Crestmont estate.

The Crestmont estate (Robert D. Farquhar, architect, 1923) as seen in 2012. *Photo by Michael Locke.*

Such matters were of little concern to the Andalusian village of Campamento, where Moreno's mother now lived and where he and Daisy went for their honeymoon. The entire village turned out to greet their native son and his American bride, demonstrating the worldwide fame that Hollywood stardom by then conferred.[111]

Upon returning to Los Angeles, Daisy hired Robert D. Farquhar (noted for his design of the Festival Hall at the 1915 Panama-Pacific Exposition in San Francisco) to build a Mediterranean-style villa on the crest of the highest hill in Silver Lake at 1923 Micheltorena Street, a property she acquired in her divorce from her first husband, oilman J.M. Danziger. Similar to Villa Monaco, the traditional European effect reminded Moreno of his homeland. The stylistic choice also might have been influenced by Moreno's fellow thespian, personal friend and new neighbor, Julian Eltinge, whose nearby Villa Capistrano had been built five years earlier. Christened the Crestmont, the Canfield-Moreno Mansion would become famous for its swank parties attended by celebrities, socialites and, in deference to Moreno, members of the Spanish- and Mexican-era land grant families. Ranking second only to soirées at the Pickfair estate of Hollywood's supreme celebrity couple, Mary Pickford and Douglas Fairbanks, an invitation to the Crestmont was the prized ticket in town.[112]

The high life was to be short-lived. As it had for Tom Mix, Hollywood's late 1920s transition to sound spelled the end of Moreno's stardom, not due to the quality of his voice but to his Spanish accent. As with other non-native speakers, foreign accents relegated one-time stars to supporting, often stereotypical roles (Greta Garbo and Marlene Dietrich were notable exceptions). Hoping to minimize the demotion, Moreno, after separating from Daisy in 1932, moved to Mexico, where he could still play the lead in, and even direct, Spanish-language films made for the Latin American market.[113]

A few weeks after their separation, returning from a party in a dense fog, Daisy died when her car tumbled down a cliff along Mulholland Drive. Shortly before the tragedy, she had bequeathed Crestmont to the Catholic Church to be turned into a school for orphaned girls. In 1953, the Franciscan Sisters of the Immaculate Conception of Our Lady of the Sacred Heart took over the property, for use as a home for orphaned and homeless girls. Plans to turn the estate into a home for retired nuns were dashed by the Whittier Narrows Earthquake of 1987, which badly damaged the already deteriorating structure and rendered it unsafe for habitation.[114]

All was not yet lost for the Crestmont, however, as part two of its history will tell.

THE CRESTMONT MANSION PART 2: THE LIFE AND TIMES OF DANA HOLLISTER

In 1988, urban developer, restaurateur and interior designer Dana Hollister purchased the former Crestmont estate for $2.25 million. Well aware of the mansion's history, Hollister renamed it "The Paramour," aptly capturing, in the word's allusion to a secret or illicit love affair, the place's romantic but also checkered past.[115]

How Hollister acquired the mansion "with no money," as she describes it, is a feat that could hardly be duplicated today. It took seven years to close escrow, during which time Hollister traveled the globe to raise the funds that eventually enabled the purchase and endowment of the estate. Growing up in Chicago, the daughter of an expatriate California member of the legendary Hollister clan (of Santa Barbara's Hollister Ranch fame), Dana Hollister grew up in a home of refinement and culture. Her father was a distinguished architect and her mother a painter and interior designer.

After graduating from Chicago Art Institute, Hollister followed her mother's lead by pursuing a career in design. Her first job at *Playboy* magazine seems incongruous for a woman of her pedigree, but it also demonstrates her independent spirit. During her tenure at *Playboy*, she designed twenty-one covers, fell in love and moved with her amour to Silver Lake. Neither the relationship nor her career at *Playboy* would survive the cross-country move, but after a brief "down and out" period, Hollister literally began stitching her life together. Armed with a sewing machine, a collection of fabric gleaned from closeouts and garage sales and her creative talent, she transformed odds and ends into designer pillows, one of which a Westside boutique was able to sell the first day for eighty dollars.

Dana Hollister. *Photo by Melissa Villadares.*

Rapidly building a lucrative product line of one-of-a-kind "shabby-chic" couture, Hollister eventually opened her own boutique, Odalisque, on Beverly Boulevard, which began to catch the eye of the Hollywood elite. One of these, director Tim Burton, dropped by one afternoon and "literally bought out everything in the store. He just loved the stuff," Hollister recalled in our interview. Moreover, their meeting created a long-standing relationship that eventually led Hollister to the discovery and purchase of the Canfield-Moreno estate.

While helping Burton in his search for a new home, Hollister happened on and instantly fell in love with the decaying mansion the Franciscan nuns

were having difficulty maintaining. Resembling the run-down Hollywood mansion at the beginning of *Sunset Boulevard*, described by the film's deceased narrator as "falling apart in slow motion," the place also meshed with Hollister's knack for spotting diamonds in the rough.

Over the next several years, Hollister and the Franciscans maintained a friendship that endured the seven improbable years of negotiation, during which the property fell out of escrow several times. Once taking over the property, her initial plan, after extensive retrofitting and restoration, was to convert the mansion into a retreat hotel along the lines of the Bel Air Hotel. When opposition from immediate neighbors nixed this idea, she found a practical and lucrative alternative in maintaining the place as a private residence and business office while also renting it out for music recording, film shoots and concerts, as well as making it available for charity events.

For those concerned about historical preservation, Hollister's restoration of the Crestmont to a condition befitting its Historical Cultural Landmark status has made her a local hero. Not one to sit still or rest on laurels, she has gone on to become a major "power player" in the Silver Lake, Echo Park and downtown Los Angeles bar and restaurant scenes. Her local business interests span a range of venues, from the gay-oriented 4100 Bar (previously the Detour) on Santa Monica Boulevard and upscale Cliff's Edge restaurant and bar on Sunset Boulevard, both in Silver Lake, to the upgraded Bright Spot coffee shop on Sunset Boulevard in Echo Park.

Hollister's most ardent dream remains creating a boutique hotel in Silver Lake, to which end she recently leased the lovely old, but unused and dilapidated, Pilgrim Church on Griffith Park Boulevard and Lucille Avenue. Again, major retrofitting and restoration pose a challenge, as has been overcoming déjà vu opposition from immediate neighbors of the church.

Whether her hotel dream is realized, Hollister's place in Silver Lake history, as salvager and restorer of the Crestmont Mansion, is secure. Villa Monaco, Villa Capistrano and other outsized Silver Lake homes notwithstanding, the renamed Paramour remains Silver Lake's largest mansion, with over fifteen thousand square feet of living space, eight bedrooms and eight baths, complete with ballroom, swimming pool and "whispering wall," not to mention an Old Hollywood ambience, expansive grounds and a near 360-degree panoramic view.

FRANK ALDERMAN GARBUTT AND THE MANSION ON HATHAWAY HILL

While the Paramour Mansion may be Silver Lake's largest and most historically significant, the mansion on Hathaway Hill (also known as the Garbutt House) is easily its most visible and most imposing. Many tales have been told about the mysterious concrete structure out of a Hitchcock film or Wyeth painting that looms above the south end of Silver Lake Reservoir; not all of them on the mark. Fortunately, through an afternoon spent in the early spring of 2014 with Frank Garbutt Hathaway (hereafter Frank Hathaway), son of Melodile Garbutt and Charles Hathaway Sr. and grandson of Frank Alderman Garbutt, I hope to set the record straight.

We met downtown at the Los Angeles Athletic Club (LAAC), which Hathaway ran for forty years as president, chief executive officer and chairman of the board until his retirement in 1992. He still attends board meetings, however, as he did on the occasion of our tête-à-tête, driving down from his home in Big Sur. Despite the long drive, he looked the picture of health, much younger than his ninety years, partially explained, one suspects, by his lifelong association with LAAC.

From my talk with Frank Hathaway, his own book on the family, Betty Young's history of the LAAC and other sources, the following remarkable story emerged.[116]

Francis Clarkson Garbutt, the only child of British immigrants, was born in 1837 "in a tiny farmhouse in the Canadian wilderness on the outskirts of what is known today as Toronto."[117] Leaving home at sixteen to "make his own way in the world," Francis Garbutt eventually worked his way through

Harvard College, married Mary Alderman and moved with her and their two-year-old son, Frank Alderman Garbutt (hereafter Frank Garbutt), to Denver, Colorado, in 1871.[118] After amassing a fortune in the Colorado mines, the Garbutts moved in 1882 to the rapidly growing frontier town of Los Angeles, where Francis quickly established himself as a player in the booming real estate market.

The family's association with the LAAC, then a bastion of the city's elite, began soon thereafter. Following his father's admission, Frank Garbutt was invited to join at the tender age of fourteen, an experience he described with a mixture of trepidation and awe: "Composed of the leading young men of the town, what a lump of ice that membership committee appeared to be. They did not look *at* you. They looked right through you. They froze the very marrow in your bones by their cold aloofness. But what a difference when they finally decided you were good enough to associate with the elect. The frigidity was replaced by compensating warmth that made the atmosphere of the Club delightful. You were a member of the Los Angeles Athletic Club! What greater stamp of approval could anyone ask?"[119]

After graduating from Los Angeles High School, Frank Garbutt dropped out of Stanford after a year, studied law on his own and learned about mining from his father. Still only nineteen, he married Emilie Laurine Eduoart, granddaughter of the eminent French-born artist Auguste Amant Constant Fidèle Edouart, and began inventing oil-drilling tools, which he sold for profit and also used to drill his own wells. By the 1890s and still in his twenties, the entrepreneurial prodigy had joined Edward Doheny and Charles Canfield as one of the city's millionaire oil kings.

Frank Garbutt's friendship with another whiz kid, future *Los Angeles Times* publisher Harry Chandler, began in 1885, when the teenaged Garbutt had a country paper route and twenty-year-old Chandler was just starting out as a *Los Angeles Times* distributor. As Frank Hathaway recounted:

> *Chandler had come to Los Angeles two years previously as a frail youth of eighteen; he invested in* Times *stock during the Depression days of the 1880s and became business manager in 1894. The men shared many interests, including journalism. [Frank] Garbutt, a vigorous and opinionated essayist, contributed his first articles to the* Times *in 1893, and later became a regular columnist.*[120]

This wasn't all he became. A veritable renaissance man with a finger in every pie, Frank Garbutt was described in the press excelling as a

"boxer, automobilist, duck hunter, pioneer aviator and yachtsman."[121] By 1906, he had the fastest yacht in the West, and his daughters Melodile and Theodora became expert sailors and rowers, Melodile winning several rowing cups and Theodora's athletic prowess extending to becoming a champion at Savate, a French form of mixed martial arts.

On the business front, he expanded his oil operations, helped found the Union Oil Company and, unsurprisingly given his wide-ranging interests, jumped into the city's emerging film industry. He became vice-president and managing director of Famous Players Lasky Corporation, formed from a merger of Adolph Zukor's Famous Players Film Company and Jesse L. Lasky's Feature Play Company in the 1910s. The company soon became known as Paramount Pictures. Seemingly at the forefront of every major Los Angeles cultural and business endeavor, Frank Garbutt helped establish the city's aerospace industry through his financing of one of the country's first airplane factories (which later became Martin-Marietta), ran a ferry service between San Pedro and Terminal Island, helped launch the Automobile Club of Southern California and was on the organizing committee for the 1932 Summer Olympics.

The Garbutt-Hathaway connection began with Melodile's marriage to shipbuilder Charles Hathaway. The association with Silver Lake began in 1923 with Frank Garbutt and Charles Hathaway's joint purchase of a property atop what was then known as Dunnigan Hill (after its previous owner Helen Dunnigan), a stone's throw from Julian Eltinge's newly built Villa Capistrano. After an old house on the property had been destroyed by fire, the thirty-five-acre lot was ripe for redevelopment. While Hathaway wanted to subdivide and sell off the parcels, Garbutt preferred keeping the property in the family by creating four different "Spheres of Influence": a home for Melodile and Charles and their six children (including Frank Hathaway); another for Frank Garbutt's son, Frank E. Garbutt; and the largest for himself, the Hitchcockian mansion at the hilltop peak. A parcel was carved out for youngest daughter Theodora; however, she would remain in her father's house until a "suitable time," meaning when she married, which she never did.

Frank Hathaway recalled growing up on the hill and attending Clifford Street School, along with other boys and girls from the neighborhood during the Great Depression:

People in our neighborhood were dirt poor in 1935. Most of the kids going to Clifford Street School came from homes whose parents were out of work.

The Garbutt House (also called the Hathaway Hill mansion), as seen in 2007. It was built by Frank A. Garbutt in 1923. *Photo by Michael Locke.*

The Hathaway family's Christmas card, 1935. *Courtesy of the Frank Garbutt Hathaway Collection.*

Charles F. Hathaway's children: James, Barbara, Frank Garbutt, John, Sylvia and Charles F. Jr., 1930. *Courtesy of the Frank Garbutt Hathaway Collection.*

Theodora and Frank A. Garbutt standing beside the family's 1940 Buick. *Courtesy of the Frank Garbutt Hathaway Collection.*

Frank Garbutt Hathaway heading off to college, 1942. *Courtesy of the Frank Garbutt Hathaway Collection.*

Some of the boys came to school barefoot because they had no shoes. Money was scarce; you could buy a gallon of gas for 12 cents or a loaf of bread for 10. We lived to the west of the school, the "richer side of town," but our folks were broke too. My parents pinched pennies like everyone else. Even my Dad, who was quite well-to-do, lost everything except the home we lived in due to the bank foreclosing on his business. Fortunately, he was able to go to work every day as general manager of the Los Angeles Athletic Club.[122]

After serving in the air force in World War II, Frank became a commercial pilot with routes to the Philippines. At the family's urging, he cut his adventure (and salary) short to become an assistant to his ailing father at the LAAC. Following the death of his grandfather Frank Garbutt in 1947 and his father, Charles Hathaway Sr., in 1948, Frank Hathaway was elected president of the LAAC in 1949, a position he held for the next twenty-five years. Then he became chairman of the board and chief executive officer until his retirement in 1992. His younger brother, Charles Hathaway Jr., succeeded him as president.

Retirement was somewhat of a misnomer for Frank, as he spent an additional seveteen years as director of the LAAC's managing partner,

Stability LLC. The next generation of Hathaways—including Frank Hathaway's daughter Karen L. Hathaway as president and his son John and nephew Steven as senior vice-presidents—continue to lead the Los Angeles Athletic Club and its allied affiliations into the future.

Theodora Garbutt was the last of the family to live on Hathaway Hill, leaving after the death of her father in 1947. The house sat empty until 1960, when "the three sumptuous residences, 35 view acres on five lots went up for sale," Frank Hathaway recalls, "offered at $725,000 with pipe organ and furnishings available. There were no takers. My mother, Melodile, who was handling the estate, had the wisdom to pull it off the market. She bided her time and sold it a few years later for $1,200,000."[123]

The houses remained vacant for several more years, as the owners battled with the city and preservationists over whether to raze the three houses and build condominiums or a large housing development. In 1978, two of the houses were torn down to make way for a one-hundred-home development, but the Garbutt house was spared. Los Angeles City Council member Peggy Stevenson represented the district at the time and fervently supported the project. After the development was completed, however, it mysteriously became a gated community, with suspicions pointing to Stevenson's complicity. When Michael Woo, a "slow growth" progressive, defeated Stevenson in a subsequent Los Angeles City Council election, his office accused Stevenson of destroying all her constituent files, removing any possible evidence of involvement with the gated community.

The Hathaway Hill Mansion was purchased in 2006 by Dov Charney, founder and, until recently, chief executive officer of Los Angeles–based American Apparel. Named one of the top one hundred most powerful people in Southern California by the *Los Angeles Times* in 2009, Charney has been praised for his fair employee wages and refusal to outsource manufacturing, as well as criticized for his highly provocative advertising. Most damaging have been charges of sexual harassment, for which he was recently stripped of the company's ownership by its board of directors—an action, as of this writing, that he is fighting. The controversy surrounding Dov Charney, while it resonates with the mansion's somewhat forbidding presence, thankfully has not affected the house's entry, since 1987, on the National Register of Historic Places.

INNOCENTI PALOMBO, MICHALE TOGNERI AND THE MANSION ON MAYBERRY STREET

Perched on a steep hillside at the border of Silver Lake and Echo Park, another lone mansion at 2508 Mayberry Street has stood sentry over the neighborhood since its construction in 1927 by Italian immigrant Innocenti Palombo. Arriving in the United States in 1909, Palombo worked as a mechanic for the *Los Angeles Times*. Eventually, he was able to purchase a few vacant lots in Silver Lake/Echo Park, on which he built three houses, among them the mansion. Designed in a Mediterranean style, Palombo went one better than Armand Monaco's homage to their homeland, rendering his villa specifically in the likeness of a small palace remembered from his youth in Vicalvi, Italy.[124]

Almost the reverse of Simon Rodia, another working-class Italian immigrant who built his idiosyncratic Watts Towers between 1921 and 1954 on the cheap, using found materials, Palombo spared no expense on his traditional-style villa. He adorned it with original hand-painted murals of mythological goddesses and kissing cherubs, with Art Deco–style chandeliers and sconces on the walls and ceilings in each room. Also unlike Rodia, whose one-of-a-kind "vernacular architecture" was intended to stand out from its surroundings, Palombo hoped that by setting such a high standard, others might follow. In subsequent years, however, only modest California bungalows were built on nearby lots.

Very little else is known about Palombo's life, except that he remained a mechanic at the *Times* throughout his life; it has been speculated that he lost his investments, like so many others, in the stock market crash of 1929.

Michale, Marina and Bianca Togneri pose for a family portrait after a seven-year separation. *Courtesy of the Togneri family.*

Villa Palombo-Togneri, Los Angeles Historic-Cultural Monument Number 971, dedicated in 2010. *Photo by Michael Locke.*

Interior of the Villa Palombo-Togneri (1927), depicted in 2012—a step back in time. *Photo by Michael Locke.*

Palombo's loss would turn out to be another's gain. Yet another Italian immigrant, Michale Togneri, had been driven to the United States from the small town of Coreglia Anteiminelli by the worldwide depression of the 1930s. Penniless and leaving behind his young pregnant bride, Marina, he settled first in Chicago, where he found the harsh weather depressing. Hearing of Southern California's Mediterranean climate and scenery, he arrived in Los Angeles at age twenty-one.

Togneri started out washing windows in the high-rises of downtown Los Angeles, fetching the princely sum of ten cents per window. But within a few short years, the resourceful immigrant had started his own window-washing business and was able to send for Marina and their first child, Bianca, then seven years old.

The purchase of Palombo's house on Mayberry Street symbolized for Togneri, as it did for Palombo, the realization of the American dream of owning one's own home. An added bonus for the two Italians was the home's reminiscence of their native land, which Togneri further enhanced by growing grapes on the expansive grounds and making wine. The Togneri family grew as well, adding two more daughters and two sons. Togneri worked well into his seventies, retiring to devote himself full-time to cooking, gardening and tending his fruit and olive trees (some of which still remain on the property).

Two of the Togneri daughters, Gloria and Clara, eventually opened a beauty salon in Silver Lake and lived in the mansion during the nearly sixty years it remained in the family. Clara, the last of the Togneris to reside in the old house, passed away in 2001. When the house was sold in 2009, it remained (as I noticed in my visits), except for the fading with time, very much as it must have first appeared in 1927. Further evoking the earlier period, a 1929 Studebaker Touring Car, likely having belonged to Palombo, was still parked in the garage, and remnants of Togneri's old wine press and wine casket lay beside his grape orchard, in the shade of the citrus grove and a lone olive tree.

The Italian American dream house of Innocenti Palombo and Michale Togneri was dedicated in 2010 as Los Angeles Historic-Cultural Monument Number 971.

From Poverty to Philanthropy: The Inspiring Success Story of George C. Page

The rags-to-riches odyssey of entrepreneur/philanthropist and transplanted Silver Lakean George C. Page should be required reading for every Angelino. Southern California's magical allure first struck Page in 1913 as a twelve-year-old schoolboy in his native Fremont, Nebraska, when a teacher handed him an unfamiliar object—a sweet-smelling golden orange. "I was so awed by the beauty and fragrance of that piece of fruit," he later recalled, "I vowed to live someday where it came from."[125]

A premature nudge in his dreamland's direction came four years later, when his alcoholic stepfather metaphorically announced, "It's time to paddle your own canoe."[126] Page promptly packed his worldly possessions in a shoebox, bade farewell to his loving mother and hitchhiked to Los Angeles, arriving with $2.30 in his pocket. Working odd jobs and living hand-to-mouth, he hit on an idea one Christmas that inadvertently jump-started his entrepreneurial career. Thinking it would be nice to surprise folks back home with a holiday gift package filled with the wondrous exotic fruits people took for granted in California, he packed up some oranges, tangerines, avocados, pomegranates and dates; lined the box with red crepe paper; and added some tinsel for good measure. When other boarders in his rooming house saw the novel gift package, they asked him to do the same for them. Thirty-seven gift boxes later, he not only had made some decent money but also realized that he could make a business out of this.[127]

With the money from his makeshift operation, he rented a store on Hill Street downtown in 1918 and opened his first shop. In a few short years, he

The George C. Page estate, 2178 Kenilworth Avenue in Silver Lake (Angelus Architectural Services Company, 1927), as seen in 2012. *Photo by Michael Locke.*

owned one hundred stores from San Francisco to San Diego, with more than one thousand employees, under the name "Mission Pak," whose catchy (if somewhat dated) jingle became a household refrain: "A gift so bright, so gay, so light…give the Mission Pak magic way!"[128]

After traveling the world on his earnings, Page, at the still-young age of twenty-seven, decided to settle down in Silver Lake. Purchasing a vacant lot in the Moreno Highlands section overlooking the reservoirs in 1928, he built an English Tudor–style mansion at 2178 Kenilworth Avenue that remains in place today.[129]

Having gained entrée into the city's loftier social circles, Page attended a gathering of Los Angeles's French-speaking community hosted by actor Charles Boyer, where he met his future wife, Juliette Creste. On one of the couple's vacations abroad, Page stumbled on a new material called "cellophane," whose packing potential was readily apparent and soon became a fixture at Mission Pak. During World War II, Mission Pak played a patriotic role by supplying dehydrated and nonperishable foods to the military.[130]

After the war, Page sold Mission Pak and moved from Silver Lake to Malibu, buying a run-down beach house that he and Juliette turned into a

The George C. Page Museum (Thornton and Fagan Associates, AIA, 1977), as seen in 2013. *Photo by Michael Locke.*

Pepperdine chancellor Charles B. Runnels and president Howard A. White honoring benefactor George C. Page (middle), 1985. *Courtesy of Pepperdine University.*

showplace featured on the cover of *House Beautiful* magazine. Branching into real estate, he bought a sixty-acre tract in Hawthorne and subdivided it for industrial use by aerospace and electronics firms under ten-year leases. Always the expert "packager," Page's project predicted the kind of landscaping that would later become de rigueur for today's industrial parks.[131]

His wealth by this time surpassing his wildest dreams, and a widower following his wife's death from cancer in 1968, Page made a decision that became the hallmark of his life. "I asked myself," he later wrote in his autobiography, "would doubling my net worth add to my joy of living? As I thought about it, I realized that I wasn't interested in more than one home and didn't want a yacht or a string of race horses. I could sleep in only one bed and eat only three meals a day. So...I made one of the most serious decisions of my life...I am simply not one of those men who are determined to be the richest man in the cemetery!"[132]

Thus began Page's third career: as a philanthropist. One of the first beneficiaries of his generosity was the Children's Hospital of Los Angeles in East Hollywood, a private, nonprofit teaching hospital providing critical care to children. He underwrote much of its expanded construction and renovation.[133]

Similar to his childhood epiphany with the orange, Page had been awed in 1927 by his first glimpse of Los Angeles's unique urban repository of prehistoric fossils, the La Brea Tar Pits. Finding on his early visit that the precious relics had no nearby viewing site and were instead displayed several miles away at the Natural History Museum, Page hatched an idea that was realized fifty years later with the opening, in 1977, of the George C. Page Museum, directly adjacent to the tar pits (designed by Frank Thornton and Willis Fagan).[134]

Other organizations to which Page was a major donor include the George C. Page Youth Center in Hawthorne, the George C. Page Stadium at Loyola Marymount University, the arts programs at the University of Southern California and scholarships and the Law School Residential Complex at Pepperdine University.[135]

Page died in 2000. In his obituary in the *Los Angeles Times*, a quote from Page about the museum that bears his name recalls the introduction to a California orange that inspired his migration to Los Angeles and longtime sojourn in Silver Lake: "This is so living, so immediate, stretching its arms wide to indicate the distinctive burial-mound structure...It's like giving flowers that I can smell while I'm still here."[136]

19

THE MUSIC BOX STEPS

The Music Box Steps are one of the world's most revered film locations. The 133-step staircase, providing a pedestrian short-cut from Vendome Street to Descanso Drive in Silver Lake, like many constructed in the area's hilly neighborhoods in the early 1900s, served a practical purpose for local residents when cars were still a comparative luxury. For the slapstick comedies of pioneer producers Mack Sennett and Hal Roach, the steps offered irresistible comic possibilities.[137]

The famed comedy team of Laurel and Hardy first took advantage of the steps in 1927 in a now-lost silent short called *Hats Off,* in which the boys do their usual bungling best to deliver a washing machine up the steep hill. Following the transition to sound in the late 1920s, the comics, now more popular than ever, added dialogue to several of their silent films. In *The Music Box,* as the title gives away, they also switched the washing machine to a player piano, with literally smashing results. The combination of slapstick and Greek mythology—specifically, the myth of Sisyphus, who was doomed to roll a boulder up a hill only to watch it roll back down, endlessly—adds symbolic weight to what is also one of the most hilarious movies ever made.

The Three Stooges would make their own version of *The Music Box* in the 1941 short *An Ache in Every Stake.* The oafs played icemen delivering cakes of ice up another long staircase, this one located a few hills away from the Music Box Steps but still in Silver Lake, at 2258 North Fair Oak View Terrace. The kicker here is that the cakes melt into cubes by the time the Stooges reach the top. A more recent, full-length-feature variation on the theme, *A Fine Mess,*

Stan Laurel and Oliver Hardy. *Courtesy of the Watson Family Photo Archive.*

directed by Blake Edwards and starring Ted Danson and Howie Mandel, came out in 1986. Besides the title's homage to Hardy's obligatory putdown of Laurel—"This is another fine mess you've got me into!"—a player piano serves as a comical prop in Edwards's film as well.

No film can hold a candle to the original *Music Box*, however. Besides winning the first Academy Award for Best Live Action Comedy Short in 1932, the film was selected in 1997 for preservation in perpetuity by the National Film Registry, an honor bestowed each year since 1988 on twenty-five films judged by experts to be of great cultural, historical and aesthetic significance.[138] Tour buses have made the Music Box Steps a regular stop, and fans from around the world have long flocked to the legendary site to take photos of, set foot on and possibly venture all the way to the top of the seemingly endless staircase.

In 1994, community and preservation groups—the Silver Lake Improvement Association (SLIA), Hollywood Heritage, the Silent Society and the Association of Camera Operators—had a plaque emplaced

Above: .Laurel and Hardy
look-a-likes Brian Mulligan
and John Mackey with
Vincent Brook at Music Box
Steps Day, October 2007.
Photo by Michael Locke.

Left: The Music Box Steps.
Photo by Michael Locke.

Opposite: Music Box Steps
Day, October 2007. *Photo by
Michael Locke.*

in one of the bottom steps. A few years later, council member Tom La Bonge had a "Music Box Steps" signpost erected at the bottom and top of the staircase. And since 1995, SLIA, with council office and other local support, has organized an annual Music Box Steps Day family film festival to commemorate the famed location, the classic film and its incomparable, much-beloved stars, Stan Laurel and Oliver Hardy.

Film buffs of every stripe—including visitors from England, Ireland, the Netherlands and Germany and, of course, members of the Sons of the Desert (the international association of Laurel and Hardy fan clubs, or "tents" as they're called)—have made a pilgrimage to the pocket park across from the steps, since renamed Laurel and Hardy Park, to attend Music Box Steps Day. The event is the brainchild of this book's co-author, Vincent Brook, who lives a short block from the steps. A longtime Silver Lakean and Laurel and Hardy fan, Brook couldn't believe his good fortune when he discovered that his house on nearby Robinson Street was a hop, skip and jump from the steps. His idea for commemorating the steps instantly caught on with the rest of the SLIA board, whose current president, Genelle Le Vin, and co-vice-president, Mark Hummer, have been most prominent in helping put on the event, along with other board members and volunteers dedicated to honoring the steps "for the sake of local pride and as a reminder of the cinematic treasure and historic jewel in our midst."[139]

Music Box Steps Day is far from all that SLIA has been involved with since its founding in 1989 by a group of civic-minded locals devoted, as the group's mission statement avows, "to the creation and maintenance of a clean, safe and vibrant community environment." SLIA's many accomplishments have included helping organize the Silver Lake Neighborhood Council, sponsoring the Sunset Triangle Plaza at Griffith Park Boulevard and Edgecliffe Drive, holding cleanups and community meetings on pressing issues and mounting major beautification and tree-planting projects (several hundred trees have been planted so far).

But the group's pride and joy remains Music Box Steps Day, whose twentieth annual celebration took place in October 2014. Besides the usual Laurel and Hardy look-alikes, free food, a magic show, a giant raffle, educational presentations and displays and multiple screenings of the classic twenty-nine-minute film in a tent set up in the park, this very special event included a replica of the music box from the film, student films on the *Music Box* theme, a costume contest and an appearance by the grandsons of W.C. Fields. Here's hoping Music Box Steps Day, like the film and film location it honors, continues to work its magic for many years to come.[140]

PILL HILL

With views of Silver Lake Reservoir below and the verdant hillside (and eventually the Los Angeles skyline) beyond, the Moreno Highlands was destined to become a "neighborhood of first choice" soon after Antonio Moreno and Daisy Canfield built their twenty-two-room Crestmont Mansion. The Crestmont and similarly-styled Villa Capistrano, not least because of their celebrity owners, were widely covered in the press of the day, drawing sight-seers but also aspiring residents—among them other movie people, artists and intellectuals and, over time, large numbers of medical professionals. The latter influx, further attracted by Silver Lake's proximity to Los Angeles County Hospital and the University of Southern California Medical School (established in 1885), inspired a new moniker for Moreno Highlands: "Pill Hill."[141]

Among the medical newcomers was Dr. Clarence J. "C.J." Berne, chairman of the USC Department of Surgery, a position he held for thirty years, starting in 1939. Born in 1904 in Hartley, Iowa, then a Midwest outpost of the Ku Klux Klan, Dr. Berne remembered as a youngster the Klan burning a cross on his "too liberal" family's front lawn. After graduating from the University of Iowa Medical School in 1932, he moved to Los Angeles at the behest of his future mentor, Dr. Charles Rowan, professor of surgery at USC. When Dr. Rowan became crippled with arthritis, Dr. Berne pushed Dr. Rowan's wheelchair as he continued doing his rounds, which apparently inspired the 1938 film *Young Dr. Kildare* (and by association, the later 1960s television series *Dr. Kildare*).[142]

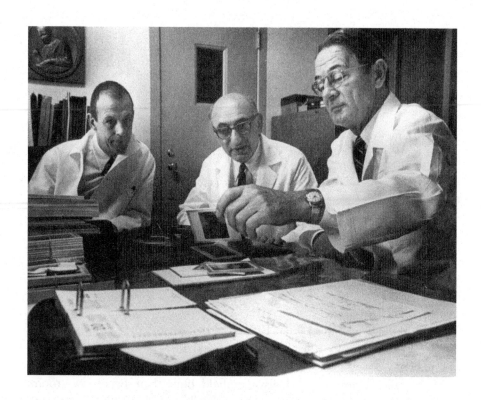

A portrait of Dr. C.J. Berne. *Courtesy of Thomas V. and Cynthia Berne.*

Opposite, top: Three legendary University of Southern California chiefs of surgery, 1937–91, Arthur Donovan, Leonard Rosoff and C.J. Berne. *Courtesy of Thomas V. and Cynthia Berne.*

Opposite, bottom: Dr. C.J. Berne residence (C. Raimond Johnson, architect, 1937), as seen in 2014. *Photo by Michael Locke.*

Having first settled in the posh neighborhood of Hancock Park south of Hollywood, Dr. Berne decided to move to the "more convenient" Moreno Highlands section of Silver Lake in 1937, selecting USC architecture professor C. Raimond Johnson to design his Mediterranean Revival–style house at 2023 Redcliff Street.

During World War II, Dr. Berne became chief of surgery for the Los Angeles County Seventy-third Evacuation Hospital, whose first mission in 1942 was to support the building of an alternative to the Burma Road in the Himalayas. The construction involved fifteen thousand American soldiers and thirty-five thousand locals, many thousands of whom died or were injured. After the war, he served as surgery department chairman at USC for another twenty-five years. His legacy is carried on by his son Dr. Thomas V. Berne, professor of surgery at USC's Keck School of Medicine, and grandson Dr. John D. Berne, a physician in private practice in Tyler, Texas.

Another giant in the medical field who ended up on Pill Hill, at 1916 Micheltorena Street (across from the Crestmont), was Dr. Kenneth Williams, the first chairman of the Los Angeles Medical Association Committee on AIDS and a pioneer in the free-clinic movement.[143] Born in 1925 to a Welsh coal miner, Williams and his family immigrated in the 1930s to New York City. Upholding the Welsh reputation for singing voices, Dr. Williams moved up from the local Welsh church choir to the Trinity Church choir in Washington Heights. Trinity also had a tradition of ministering to the poor and disadvantaged, whose numbers swelled during the Great Depression, and from this Dr. Williams got his first taste of medical service. Expanding this experience during World War II, he became a first-aid attendant in the ambulance service, trained to become a navy medical corpsman and served with a Seabee unit on Okinawa.

After the war, Dr. Williams graduated from the University of Virginia's medical school and became an expert in hematology and oncology. After a brief stint in private practice, he joined USC's Keck School in the late 1950s as an associate professor of pediatrics. During this period, he would help make crucial inroads in the treatment of children's cancer.

Together with Dr. Leslie Halve, president of the Los Angeles Pediatric Society, and the staff at Saint John's Episcopal Cathedral near USC, Dr. Williams developed a pilot program in the 1960s at the Saint Johns Well Child Center (which was a precursor to the free clinics that have since spread across the country and around the world). Becoming the center's volunteer medical director from 1977 until his retirement in 1997, Dr. Williams oversaw the center's expansion into a network of clinics across Los Angeles,

Left: A portrait of Dr. Kenneth Williams. *Courtesy of Dr. Kenneth Williams.*

Below: Dr. Kenneth Williams with Los Angeles mayor Richard Riordan. *Courtesy of Dr. Kenneth Williams.*

Sally and Ken Williams enjoying the good life at home in Silver Lake. *Courtesy of Dr. Ken Williams.*

providing primary care services through outreach, health education, child development and literacy education.

In 2005, Dr. Williams was honored with the establishment of the Dr. Kenneth O. Williams Wing of the USC/Children's Hospital Institute for Bone and Soft Tissue Tumor Research, whose mission of finding cures for childhood cancers has led to a near 80 percent survival rate among childhood cancer patients.

Observations Dr. Williams made while serving as an attending staff physician at USC Keck Hospital in the 1980s would lead to another of his major

contributions. Doctors in New York and California had begun reporting a deadly new infection centered in the gay and drug-use populations. Alarmed by the growing epidemic but confronting stubborn indifference and denial from the larger society, Dr. Williams became the first chair of the newly formed Los Angeles County Medical Association Commission on AIDS, which proved a turning point in the humanitarian crisis. His and the commission's practical, no-nonsense approach—perhaps most effectively expressed through its educational films and billboard campaigns—were key factors in the public and medical community's finally coming to grips with the catastrophe.

Dr. Williams, whose wife, Sally, died in 2014 after a long illness, recently moved from Silver Lake to Michigan to be near his grandchildren.

THE CONTRADICTORY SAINT:
SISTER AIMEE SEMPLE MCPHERSON

Architecture, Hollywood and good works come together in spectacular fashion in the adventures of Sister Aimee Semple McPherson, her International Church of the Foursquare Gospel and the cavernous Angelus Temple she built across from Echo Park Lake in 1923. At a time when women were to be "seen and not heard," Sister Aimee, as she came to be known, broke all the rules, becoming one of Los Angeles's most visible (and ultimately controversial) celebrities. Another figure with Elinor Glyn's "It" factor, Sister Aimee's boon, and eventual bane, was the fact that her sex appeal emanated not from a movie star or pop singer but from a preacher of the sacred word.

Aimee Semple McPherson was born on a farm in the small village of Salford in Ontario, Canada, in 1890. From her father, the choirmaster and organist of the local Methodist church, she learned to play both the organ and piano but not, at least initially, reverence for the Lord. Eschewing her parents' piety, she was deemed a "party girl" in her teens and liked to go to dances and movies and wear makeup. Impressed in 1907 by a revival service, however, and especially by the handsome evangelist minister, Robert Semple, Aimee abruptly dropped her secular ways, embraced the Christian faith and accepted Robert's proposal for marriage the following year.[144]

The marriage ended tragically when Robert, during the couple's missionary work in China, died of malaria in 1910. Aimee also contracted, but recovered from, the disease and moved with her newborn daughter to New York City. While doing charity work at the Salvation Army, she met and

A Sister Aimee Semple McPherson whistle stop. *Courtesy of the Watson Family Photo Archive.*

married Harold McPherson, with whom she began ministering as a team. As Aimee's evangelical (and "It" factor) charisma began to blossom, she began touring on her own, while Harold, unable to handle playing second fiddle, filed for divorce. The breakup didn't slow Aimee's evangelical ascent and

likely helped spur her increasingly colorful style, such as delivering sermons across the country in 1916 from the back seat of a Packard convertible, dubbed the "Gospel Car," and starting her own magazine, *Bridal Call*.[145]

Moving from the Gospel Car to the nation's Car Capital in 1918 might have been a logical progression, but Sister Aimee dramatically announced her arrival in Los Angeles as coming from a direct order of the Holy Spirit. Finding Echo Park/Silver Lake's unconventional spirit especially congenial, she built the gargantuan Angelus Temple, a prototype of today's' mega-churches, on Glendale Boulevard just south of Sunset. The auditorium, despite a seating capacity of 5,300, was filled three times a day, seven days a week. Ensconced in the world's film capital and with studios just around the corner, Sister Aimee tapped into the entertainment scene and began preaching on radio (on her own station) and creating vaudeville-style services replete with lavish costumes, live animals and, on occasion, even an airplane. Movie stars such as Charlie Chaplin and Gloria Swanson, if only for the bizarre spectacle, were known to frequent the church. Eventually surpassing fellow theatrical evangelist Billy Sunday in popularity, one paper hyperbolized, "Neither Houdini nor Teddy Roosevelt nor PT Barnum had such an audience."[146]

All was not bells and whistles, of course. Combining a rabid anti-Communism with Social Gospel populism, Sister Aimee and the Foursquare Church catered ardently to the needs of the poor, especially during the Depression, offering food, shelter and other assistance.[147]

As might be expected, along with Hollywood-style stardom came a Hollywood-style scandal. In 1926, Aimee went for a swim at Ocean Park Beach and disappeared. She was first believed to have drowned, but a month later, her mother received a letter demanding $500,000 in ransom and threatening to sell Aimee into white slavery. Then a month later—suspiciously for some, a miraculous resurrection for others—Sister Aimee walked across the Mexican border at Douglas, Arizona, claiming she had been kidnapped, drugged and tortured but, by the grace of God, had managed to escape.[148]

Opposite, top: The disappearance of Aimee Semple McPherson in a photo montage by George Watson. *Courtesy of the Watson Family Photo Archive.*

Opposite, bottom: A crowd of fifty thousand greet Aimee Semple McPherson at Santa Fe Station on her return to Los Angeles after her sensational "kidnapping." *Photo by George Watson. Courtesy of the Watson Family Photo Archive.*

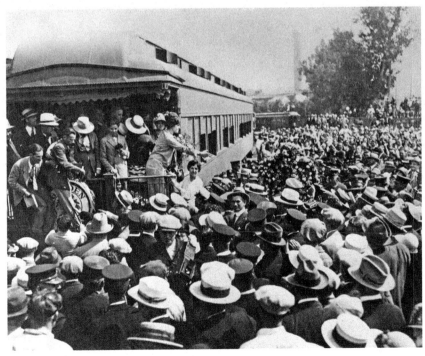

Sister Aimee Semple McPherson's Silver Lake home (John Pederson, architect, 1941), as seen in 2012. *Photo by Michael Locke.*

Angelus Temple (A.F. Leicht, architect, 1923), as seen in 2008. *Photo by Michael Locke.*

During a grand jury investigation that attracted the nation's press, evidence appeared to contradict Aimee's account. Her shoes were not scuffed after her alleged trek from Mexico, and she had borne no signs of mistreatment. Most damning, five witnesses testified to spotting her at a seaside cottage accompanied by an alleged lover, Kenneth Ormiston, a married engineer at the church's radio station, who had disappeared at the same time. Though Aimee managed to avoid being charged with any infraction, her saintly reputation suffered.[149]

A bedrock of loyal supporters allowed her to continue her ministry and the Foursquare Church to flourish, but for Aimee, personally, the post-trial years were a roller-coaster. In 1929, she built an elaborate Moroccan-style fantasy house at Lake Elsinore, dubbed "Aimee's Castle," adorned with onion domes and a minaret. In 1930, she suffered a nervous breakdown. In 1931, she married actor David Hutton, whose ex-girlfriend sued him for breach of contract, and in 1934, they divorced. In 1939, she sold her Elsinore castle, and in 1941, she had a Spanish Colonial–style home built in the Moreno Highlands at 1982 Micheltorena Street, where neighbors regularly witnessed her baptizing the faithful in the backyard pool and reported seeing a large oval mirror attached to the ceiling in her master bedroom.[150]

Sister Aimee preached her last sermon in Oakland in 1944, dying the next day from an accidental overdose of a prescription drug. People lined the block at Angelus Temple to view her body in state, and her funeral was one of the largest ever held in Los Angeles. The Foursquare Church, meanwhile, has grown exponentially: as of 2000, according to the church website, worldwide membership is over 8 million, with almost 60,000 churches in 144 countries; and in 2006, membership in the United States alone was listed as 353,995 in 1,875 churches.[151]

Of particular interest to the local community, Foursquare Church has recently partnered with Matthew Barnett's Assembly of God Church, located in the Dream Center (former Queen of Angels Hospital) at 2301 Bellevue, overlooking the 101 Freeway in Silver Lake. The Dream Center's religious services, led by Pastor Barnett, have become the primary ones held at Angelus Temple. And, like Foursquare, the Dream Center follows the Social Gospel, working to rehabilitate gang members, drug addicts, unwed mothers, children without parents and others in need (taking in hundreds of refugees, for example, after Hurricane Katrina).[152] The Dream Center's most innovative program is the Los Angeles Gang Tours, started by ex-gang member Alfred Lomas. Sounding like a parody of the city's Movie Star Tours, Los Angeles Gang Tours actually upholds Sister Aimee's dual legacy

by tapping global tourist appeal to address gang-related problems. "Culture changes culture," Lomas remarked on one of his tours, whose mission is to raise public awareness and funds for rehabilitation. Sister Aimee surely would approve.[153]

CONCLUSION

Forbes magazine, in 2012, rated Silver Lake the "Best Hipster Neighborhood" in the United States, beating out San Francisco's Mission District and Brooklyn's Williamsburg. "Nestled between Echo Park and Los Feliz," columnist Morgan Brennan wrote, "the trendy community boasts some of the nation's most lauded food trucks and farmers markets, a multicultural blend of residents with eclectic professions, and a booming arts scene. Even the buildings exude an avant-garde aesthetic a hipster could love: Silver Lake is home to some of the most celebrated modernist architecture in the country, including Richard Neutra's Van der Leeuw Research House and John Lautner's Silvertop."[154]

Except for the architectural nod, what is missing from Brennan's analysis, and which contributes immeasurably not only to Silver Lake's hipness but also to its uncommon charm, is its rich history. This book, in its chronicling of some of the area's more familiar and largely forgotten people and places, has reflected on this vibrant past and highlighted the qualities that have helped make Silver Lake the exciting and supremely livable urban oasis it has become.

These qualities include the unique topography: the once pastoral, still-lush hills and glens that inspired the area's first English-language name, Edendale. This distinctive landscape continues to provide an intimacy and coherence to Silver Lake and neighboring communities generally lacking in the so-called Plains of Id—British cultural critic Reyner Banham's pejorative term for the sprawling, nondescript flatlands that characterize much of the rest of Los Angeles.[155]

The natural qualities come to a crescendo in the Ivanhoe and Silver Lake Reservoirs. These names harken back, in Ivanhoe, to a nineteenth-century romantic sensibility and, in Silver, to a man whose professional career and vision were directed toward the future. These romantic and modern facets, as the individual stories recounted here show, course through Silver Lake's past and present to a remarkable degree.

The film industry, much of which got its West Coast jump-start in Edendale, offers one of the most striking examples of this romantic/modern intersection. Only made possible through the latest technology and reflecting the needs and values of an urbanized society, the Western films of Colonel William Selig and Tom Mix, many shot in the immediate area, are steeped in a part-real, part-imagined past aptly described in a 1914 oater's opening title card: "The West! The Land of vast golden silences where God sits enthroned on the purple peaks and man stands face to face with his soul."[156]

Jazz Age and Victorian attitudes met head-on in the movie-star scandals of the 1910s and 1920s, two of the most prominent of which crippled the careers of Silver Lake living or working stars Mabel Normand and Roscoe Arbuckle. The lives and lifestyles of Silver Lake–based Antonio Moreno and Julian Eltinge further underscore the movies' intertwining modern and romantic elements. Though Moreno's Latin Lover appeal was a product of a 1920s historical moment, his persona evoked the novel *Ramona*'s Mexican-era fantasy of sensuous señoritas and gallant caballeros.

The Italianate style of his and Daisy Canfield's Crestmont estate, meanwhile, was built on movie and oil industry money that had helped propel Los Angeles into the modern age. As for Eltinge, while his female impersonator profession clearly spoke, if still precariously, to the changing mores of the modern metropolis, his Villa Capistrano, both in name and architectural style, upheld romantic ideals of a bygone era.

The several other Silver Lake mansions discussed here, built in classical European styles for forward-thinking capitalists, upwardly mobile immigrants, cutting-edge physicians and mega-church ministers, continue the modern/romantic dialectic—one that expands exponentially if one includes the iconic modernist homes sitting cheek by jowl with the more traditional mansions. Exploring this last, intriguing cultural dynamic, however, will have to await a possible sequel to this book—or another intrepid author's plunge into Silver Lake's storied past.

NOTES

INTRODUCTION

1. The 1830s designation, as will be expanded below, is suggested on the Silver Lake website "About the Silver Lake Community, Los Angeles, California." The listing of current townships within former Edendale's borders is derived from a copy of an official city map in the possession of Mack Sennett Studios, Los Angeles, CA.

2. Though continually refined by new archaeological discoveries, precise dating of the arrival of indigenous peoples to the area remains speculative. The dates given here are from McCawley, *The First Angelinos*.

3. Ibid.

4. The later-named Los Angeles River was named Porciúncula by the Franciscan monks in honor of a church near Assisi, Italy.

5. This material is available from various sources, but a good place to start is with Kramer, Mennes and Stanley, *75th Anniversary*.

6. See Brook, *Land of Smoke and Mirrors*; United States Census Bureau statistics, www.census.gov.

7. See DeLyser, *Ramona Memories*.

Chapter 1

8. Silver Lake website "About the Silver Lake Community, Los Angeles, California."

9. Dakin, *A Scotch Paisano*, 2. Much of the general information on Reid is likewise gleaned from Dakin's text, which, as its subtitle indicates, is based on Reid's letters. The letters themselves are contained in Heizer, *Indians of Los Angeles County*.

10. Silver Lake website "About the Silver Lake Community."

11. Other Scottish-named streets in Silver Lake include Kenilworth, Hawick, Ben Lomond, Saint George (for Saint George the Dragon Slayer) and—why beat around the bush—Scotland.

12. Edwardson, "Semi Tropic Spiritualists Tract Cut in 1905."

13. Those Tongva who were housed in the San Gabriel, San Fernando and San Juan Capistrano missions were given similar-sounding names by the Spanish: Gabrieleño, Fernandeño or Juaneño. The most common designation became the slightly altered Gabrielino. As a reminder of their checkered past, present-day Tongva now formally refer to themselves as Gabrielino-Tongva. See McCawley, *First Angelinos*.

14. The second silent version, directed by Donald Crisp and starring Ada Gleason, was released in 1916; the third, directed by Edwin Carewe and starring Dolores Del Rio, was released in 1928. For more on *Ramona* in general and the Griffith and King versions in particular, see Brook, *Land of Smoke and Mirrors*; on the recently restored Carewe version (the Crisp version remains fragmentary), see Vincent Brook, "Ramona Resurrected: The Long Lost 1928 Film Adaptation Resurfaces," *Los Angeles City Historical Society Newsletter* 47, no. 2 (Summer 2014): 11, 15. Another version of the article is available online at www.tft.ucla.edu/mediascape/blog/?p=2243.

15. Heizer, *Indians of Los Angeles County*.

Chapter 2

16. The war radically altered the maps of both the United States and Mexico, with the United States gaining (most would say confiscating) close to one-half of Mexican territory, including the present-day states of California, Nevada, New Mexico and Utah, and most of Arizona and

Colorado. Texas, which Mexico had still recognized as its territory despite its defeat in the war of 1835–36, also now became an undisputed part of the United States.

17. Los Angeles Water and Power, "The City Owns Its Water."

18. Ibid.

19. Ibid.

20. Reems have been written about the aqueduct project, which most regard as a massive boondoggle to enrich Los Angeles's wealthy elite. The main issues are twofold: first, the hoodwinking of Owens Valley residents into selling their water rights without their benefiting from the aqueduct (as they were led to believe they would) and second, alleged insider knowledge that encouraged Los Angeles's power brokers to purchase San Fernando Valley property on the cheap, knowing that property values would skyrocket once the valley gained access to Owens River water and the area was annexed by the city. For a concise summary of this highly complex subject and its ramifications, which persist to this day, see Brook, *Land of Smoke and Mirrors*, 128–32.

21. Mulholland, *William Mulholland and the Rise of Los Angeles*, 138.

22. Ibid.

23. Silver Lake Reservoirs Conservancy, "Mission Statement."

24. Erie, *Beyond Chinatown*, 39. Though Mulholland largely escaped the odor of corruption around the Owens River project, his reputation would be shattered in 1928 by the Saint Francis Dam disaster, whose rupturing and flooding cost upward of 450 lives. More recent information, however, suggests that Mulholland could not have been aware, given the knowledge of the time, that a reactivated earthquake fault was responsible for the rupture (see Brook, *Land of Smoke and Mirrors*, 132).

CHAPTER 3

25. Rudd, *Jews of the Intermountain West*.

26. Personal interview with Hynda Rudd, August 14, 2012.

27. According to the website "Herman Silver" (www.jmaw.org/herman-silver-los-angeles-jewish-civic-leader-pioneer-water-commissioner), Silver was born in Magdeburg, Germany. Given Hynda Rudd's extensive research, however, we are deferring to her on this point.

28. Personal interview with Hynda Rudd.

29. Newmark, *Sixty Years in Southern California*, 595. For more on Jews in early Los Angeles, see Dinkelspiel, *Towers of Gold*.
30. *Los Angeles Times* (1896), in "Silver Clippings," 5. The book, in the personal collection of Hynda Rudd, is a collection of press clippings from 1896 to 1908.
31. *Los Angeles Record* (1896), in "Silver Clippings," 8.
32. *Capitol* (1897), in "Silver Clippings," 8.
33. *Los Angeles Times* (1900), in "Silver Clippings," 32.
34. *Los Angeles Herald* (1900), in "Silver Clippings," 43.
35. No paper or date listed, in "Silver Clippings," 56. The quote is from a speech by Major H.T. Lee during Los Angeles City Council proceedings, likely in 1898 or 1899, at which Silver was voted a salary of $250 a month.
36. *Los Angeles Herald* (no date), in "Silver Clippings," 56.
37. Mulholland's recommendation is the information given in the *Request for Historical Cultural Monument Declaration* for the Silver Lake and Ivanhoe Reservoirs, January 9, 1989.

CHAPTER 4

38. The bulk of the material in this chapter is from Mary Bonadiman's typed and handwritten records. Portions of the material later appeared in local newspapers as follows: *Griffith Park News*, July 29, 1976; *Northwest Leader*, August 12, 1976; and *Parkside Journal*, July 29, 1976.
39. Ibid.
40. Ibid.

CHAPTER 5

41. The bulk of this chapter's information comes from personal interviews with Daniel Watson, son of Garry Watson, between October 2013 and August 2014.
42. Typewritten notes from a chapter of Coy Watson Jr.'s unpublished life story, *Watson and Wimer Background and Courtship*. See also Watson, *Keystone Kid*.
43. Watson, *Watson and Wimer Background and Courtship*.

44. Harrison, "Watson Family Photographic Archive."
45. Delmar Watson Photography Archive, "Watson Family Photo Archive."

CHAPTER 6

46. United States Census Bureau statistics, www.census.gov; Crump, *Ride the Big Red Cars.*
47. Crump, *Ride the Big Red Cars*, 28.
48. Zimmerman, *Paradise Promoted*, 27.
49. Crump, *Ride the Big Red Cars*, 34.
50. Ibid., 36.
51. Ibid., 45.
52. Butler Enger, "Designing the Hyperion Viaduct at Los Angeles."
53. Zimmerman, *Paradise Promoted*, 200. For more on Los Angeles's rail to freeway turn, including discussion of the alleged auto and oil company conspiracies memorialized in the 1988 film *Who Framed Roger Rabbit*, see Scott L. Bottles, *Los Angeles and the Automobile: The Making of the Modern City* (Berkeley: University of California Press, 1987).
54. Red Car Property. "Silver Lake's Stonehenge."
55. Gerber, "Corralitas Red Car."

CHAPTER 7

56. Zimmerman, *Paradise Promoted*, 90.
57. Fine, "Introduction."
58. Sponholtz, "A Brief History of Road Building."
59. *Los Angeles Times,* July 30, 1904.
60. Ibid.

CHAPTER 8

61. Erish, *Col. William N. Selig*, 1.
62. Ibid., 7.

63. Ibid., 9.
64. Ibid., 10.
65. Most of the cartel's members were fading from the scene by the time the Supreme Court declared it in violation of anti-trust laws in 1915.
66. See Brook, *Land of Smoke and Mirrors*; also Wannamaker and Nudelman, *Images of America: Early Hollywood*.
67. Erish, *Col. William N. Selig*, 106.
68. Lincoln Heights Los Angeles. "Selig Zoo and Movie Studio."

CHAPTER 9

69. Although Arbuckle debuted as a screen actor with Selig Polyscope, he only became a star once he moved to Mack Sennett's Keystone Film Company.
70. Sennett, *King of Comedy*, 23–24.
71. Walker, *Mack Sennett's Fun Factory*, 15.
72. Ibid, 25.
73. Russell, *Mabel*, 21.
74. Ibid., 187.
75. Ibid., 38.
76. Ibid., 79.
77. Edmonds, *Frame-Up!*, 244. On the anti-Semitism issue, see Brook, *Land of Smoke and Mirrors*.
78. Russell, *Mabel*, 177. On the Taylor murder, see also Charles Higham, *Murder in Hollywood: Solving a Silent Screen Mystery* (Madison: University of Wisconsin Press, 2004).
79. Russell, *Mabel*, 218.
80. Ibid., 212, 227–30.
81. Walker, *Mack Sennett's Fun Factory*, 226.
82. Russell, *Mabel*, 13.

CHAPTER 10

83. Edmonds, *Frame-Up!*, 15.
84. Ibid., 16.

85. Nichols, "Home Video: Arbuckle Shorts, Fresh and Frisky."
86. Edmonds, *Frame-Up!*, 59.
87. Ibid., 169
88. Ibid., 247.
89. Ibid., 274.
90 Personal interview with Genelle LeVin; Cooper, Lynch and Kurtz, *Images in America: West Adams*, 35. For more on the area's star homes, see Seligman, *Los Feliz*.

Chapter 11

91. Hopalong Cassidy and Lash LaRue were among the few western stars who defied the white-hat hero rule.
92. Mix, *Life and Legend of Tom Mix*, 43.
93. Chuck Anderson, "The Old Corral." The site also discusses Ruth Mix in an article titled "The Heroines: Nadine Ruth Jan Mix, 1912–1977."
94. Ibid. Movie companies had resisted giving their main actors (and other personnel) screen credit for fear of the larger salaries they might then command. Carl Laemmle's fledgling company IMP (Independent Motion Pictures, later Universal) broke the taboo with Lawrence, soon followed by other "name" players, and created a star system that quickly became an integral (and lucrative) part of the movie business. See, for example, Sklar, *Movie-Made America*.
95. Mix, *Life and Legend of Tom Mix*, 114.
96. Menefee, *First Male Stars*, 180.
97. Mix, *Life and Legend of Tom Mix*, 111.
98. Ibid., 154–55.

Chapter 12

99. Information in this chapter comes principally from correspondence with Leslie Ferrera Ruelas—whose mother stayed with the Monaco family during a difficult period—and through research provided by historian Helene Demeestere.
100. Other architects working on the housing projects were P.A. Eisen as lead architect, in collaboration with Norman F. Marsh, Herbert Powell,

A.R. Walker and David D. Smith. Los Angeles Conservancy, "Explore L.A. Modern Architecture in America."

101. Portland Cement Association, Structural Bureau, "August 1950 Concrete Information No. AC 10, Second Edition."

102. The material on Angelina Coppola is from the online article "Valentino: Valentino's forgotten admirer" by Allan R. Ellenberger (http://allanellenberger.com/tag/angelina-coppola), which incorporates material from a book by Roger C. Peterson, *Valentino: The Unforgotten* (Los Angeles: Wetzel Publishing, 1937). Peterson was an early custodian of the Cathedral Mausoleum.

CHAPTER 13

103. Julian Eltinge Project, "The Julian Eltinge Biography." The general information in this chapter is also from the Julian Eltinge Project and, particularly as it relates to Silver Lake, from Hurewitz, *Bohemian Los Angeles*. Both Hurewitz and Faderman and Timmons, *Gay L.A.*, refer to Eltinge as a homosexual.

104. Julian Eltinge Project, "The Julian Eltinge Biography."

105. For more on the "Swish Alps" sobriquet and Harry Hay, see also Brook, *Land of Smoke and Mirrors*, 217.

106. Ibid., 223.

107. Ibid.

CHAPTER 14

108. Moreno, "The True Story of My Life," n.p.; Menefee, *First Male Stars*, 199.

109. Menefee, *The First Male Stars*, 200–01.

110. On rumors about Moreno and Canfield's sexuality, see various websites and of course Kenneth Anger's notoriously gossipy *Hollywood Babylon* (San Francisco: Straight Arrow Press, 1975). On Valentino, see, more reliably, Emily W. Leider, *Dark Lover: The Life and Death of Rudolph Valentino* (New York: Penguin, 2004).

111. Golden, "Antonio Moreno, the 'It' Man."

112. Ada Brownell, "Crestmont-Canfield Moreno House," typewritten notes from the Ada Brownell papers, n.d. The guest book from those glory days, preserved by the mansion's current owner, Dana Hollister, indeed reads like a who's who of early Hollywood.
113. Menefee, *First Male Stars*, 209–10.
114. Personal interview with Dana Hollister, December 2003.

CHAPTER 15

115. This chapter is drawn in its entirety on the author's personal interview with Dana Hollister, December 2003.

CHAPTER 16

116. Personal interview with Frank G. Hathaway, February 27, 2014; Hathaway, *Letters Home*; Young, *Our First Century*; Hathaway, *Making His Own Way*; Meares, "The Garbutt House in Silver Lake."
117. Hathaway, *Making His Own Way*, inside cover.
118. Meares, "The Garbutt House in Silver Lake."
119. Young, *Our First Century*, 55.
120. Personal interview with Frank G. Hathaway. Chandler would later marry *Los Angeles Times* founder Harrison Gray Otis's daughter Marion and become sole owner of the paper upon Otis's death in 1917. An unabashedly rightwing paper under Otis and Chandler, Harry's grandson Otis Chandler would shift the paper to the moderate left in the 1960s. In 2000, the longtime locally owned, family-run *Times* was sold to the Chicago-based Tribune Company, to which, after considerable wheeling and dealing, it still belongs.
121. *Los Angeles Times*, May 22, 20, 1904.
122. Personal interview with Frank G. Hathaway.
123. Ibid.

Chapter 17

124. The bulk of the information in this chapter is derived from personal interviews with various members of the Togneri family, beginning in 2003 and resuming in 2008. This material eventually formed the prime basis for the mansion's achieving historical cultural monument status.

Chapter 18

125. Page, *Life Story*, 26.
126. Ibid.
127. Ibid., 46.
128. Ibid., 65.
129. Myrna Oliver, "Page obituary."
130. Page, *Life Story*, 91–2.
131. Ibid., 101–02.
132. Ibid., 104.
133. Ibid., 106–08.
134. Ibid., 125.
135. Ibid., 137.
136. Quoted in Oliver, "Page obituary."

Chapter 19

137. This chapter is based on material supplied by Vincent Brook, founder/organizer of Music Box Steps Day.
138. National Film Registry, "National Film Registry Titles 1989–2013."
139. Vincent Brook, quoted in the Silver Lake Improvement Association's annual Music Box Steps Day "News Release."
140. *The Music Box* (1932, 29 min.): Producer: Hal Roach. Director: James Parrot. Starring Stan Laurel and Oliver Hardy. Supporting Cast: Gladys Gale, Billy Gilbert, Charlie Hall, Lilyan Irene and Sam Lufkin. Camera: Walter Lundin and Len Powers. Editor: Richard Currier. Dialogue: H. M. Walker. Sound: James Greene.

CHAPTER 20

141. Ryon, "Silver Lake Rustic Redefined."

142. Personal interview with Dr. Thomas Byrne, March 28, 2014.

143. The material on Dr. Williams is from a personal interview with him on April 4, 2005.

CHAPTER 21

144. Blumhofer, *Aimee Semple McPherson*, 77.

145. Ibid., 119.

146. Quoted in Epstein, *Sister Aimee*, 156.

147. Sutton, *Aimee Semple McPherson and the Resurrection of Christian America*, 191–92. Another of Sister Aimee's positive bequeathals are the lotus flowers that have become a prominent feature of Echo Park Lake. According to a historical plaque alongside the lake, Aimee brought the first lotus flowers from China in the 1930s. An annual Lotus Blossom Festival has been held, with some interruptions, since 1972, at the cluster of flowers closest to Angelus Temple.

148. *Sister Aimee*, Episode 10 of *The American Experience* series on PBS, April 2, 2007.

149. Epstein, *Sister Aimee*, 289, 307.

150. Personal interview with Dr. Thomas Byrne, March 28, 2014.

151. The Foursquare Church, www.foursquare.org.

152. Dream Center, www.dreamcenter.org.

153. Quoted in Brook, *Land of Smoke and Mirrors* (based on a tour taken by Brook).

CONCLUSION

154. Brennan, "America's Hippest Hipster Neighborhoods."

155. Banham, *Los Angeles*.

156. The line is from *The Bargain* (1914), as cited in Zimmerman, *Paradise Promoted*, 22.

BIBLIOGRAPHY

Anderson, Chuck. "The Heroines." *The Old Corral.* http://www.b-westerns. com/ladies31.htm.

Banham, Reyner. *Los Angeles: The Architecture of Four Ecologies.* 1971. Reprint, Harmondsworth, UK: Penguin, 1984.

Blumhofer, Edith L. *Aimee Semple McPherson: Everybody's Sister.* Grand Rapids, MI: William B. Eerdmans Publishing, 1993.

Bowser, Eilleen. *History of the Cinema 2: The Transformation of Cinema, 1907– 1915.* Berkeley: University of California Press, 1994.

Brennan, Morgan. "America's Hippest Hipster Neighborhoods." *Forbes.* http://www.forbes.com/sites/morganbrennan/2012/09/20/americas-hippest-hipster-neighborhoods.

Brook, Vincent. *Land of Smoke and Mirrors: A Cultural History of Los Angeles.* New Brunswick, NJ: Rutgers University Press, 2013.

Brownlow, Kevin. *The Parade's Gone By…* Berkeley: University of California Press, 1968.

Butler, Merrill, and A.L. Enger. "Designing the Hyperion Viaduct at Los Angeles." *Engineering News-Record* (Los Angeles, CA), March 20, 1930.

Cooper, Susan Tarbell, Don Lynch and John G. Kurtz. *Images in America: West Adams.* Charleston, SC: Arcadia Publishing, 2008.

Corralitas Red Car Property. "Silver Lake's Stonehenge." *Corralitas Red Car Property.* http://redcarproperty.blogspot.com.

Crump, Spencer. *Ride the Big Red Cars: How Trolleys Helped Build Southern California.* Los Angeles: Trans-Anglo Books, 1962.

Dakin, Susanna Bryant. *A Scotch Paisano: Hugo Reid's Life in California, 1832–1852, Derived from His Correspondence.* Berkeley: University of California Press, 1939.

Davis, William Heath. *Seventy-Five Years in California.* San Francisco: John Howell Books, Limited Edition, 1967.

Delmar Watson Photography Archive. "Watson Family Photo Archive." *Delmar Watson Photography Archive.* http://www.delmarwatsonphotos.com/aboutfamily.html.

DeLyser, Dydia. *Ramona Memories: Tourism and the Shaping of Southern California.* Minneapolis: University of Minnesoata Press, 2005.

Deverell, William: *Whitewashed Adobe: The Rise of Los Angeles and the Remaking of Its Mexican Past.* Berkeley: University of California Press, 2004.

Dinkelspiel, Frances. *Towers of Gold: How One Jewish Immigrant Named Isaias Hellman Created California.* New York: Saint Martin's Press, 2008.

Dream Center. www.dreamcenter.org.

Edmonds, Andy. *Frame-Up! The Untold Story of Roscoe "Fatty" Arbuckle.* New York: William Morrow and Company, 1991.

Edwardson, Diane. "Semi Tropic Spiritualists Tract Cut in 1905." *Corralitas Red Car Property.* http://redcarproperty.blogspot.com/2008/10/semi-tropic-tract-cut-in.html.

Emler, Ron, and Susan Borden. *Ghosts of Echo Park: A Pictorial History.* Newly revised, Los Angeles: Echo Park Publishing, 2000.

Epstein, Daniel Mark. *Sister Aimee: The Life of Aimee Semple McPherson.* Orlando, FL: Harcourt Brace, 1993.

Erie, Stephen P. *Beyond Chinatown: The Metropolitan Water District, Growth, and the Environment in Southern California.* Stanford, CA: Stanford University Press, 2006.

Erish, Andrew A. *Col. William N. Selig, the Man Who Invented Hollywood.* Austin: University of Texas Press, 2012.

Estrada, William David. *The Los Angeles Plaza: Sacred and Contested Spaces.* Austin: University of Texas Press, 2008.

Faderman, Lillian, and Stuart Timmons. *Gay L.A.: A History of Sexual Outlaws, Power Politics, and Lipstick Lesbians.* New York: Basic Books, 2006.

Fine, David. "Introduction." In *Los Angeles in Fiction: A Collection of Essays.* Revised. Albuquerque: University of New Mexico Press, 1995.

Foursquare Church. www.foursquare.org.

Gabler, Neal. *An Empire of Their Own: How the Jews Invented Hollywood.* New York: Crown, 1998.

Gerber, Marisa. "Corralitas Red Car Land a Step Closer to Becoming a Park." *Los Angeles Times,* May 19, 2014. www.latimes.com/local/la-me-red-car-silver-lake-20140.

Golden, Eve. "Antonio Moreno, the 'It' Man." *Films of the Golden Age* 7 (Winter 1996). http://www.filmsofthe goldenage.com/foga/1996/winter/amoreno.shtml.

Harrison, Scott. "Watson Family Photographic Archive." *Los Angeles Times*, September 29, 2010. http://framework.latimes.com/2010/09/29/watson-family-photographic-archive-3.

Hathaway, Frank G. *Letters Home: Memoirs of a WWII Troop Carrier Pilot.* Victoria, BC: Trafford Publishing, 2006.

Hathaway, Karen L. *Making His Own Way: A Biography of Frank Clarkson Garbutt.* Nashville, TN: Cold Tree Press, 2008.

Heizer, Robert F., ed. *The Indians of Los Angeles County: Hugo Reid's Letters of 1852.* Los Angeles: Southwest Museum Press, 1968.

Hurewitz, Daniel. *Bohemian Los Angeles and the Making of Modern Politics.* Berkeley: University of California Press, 2007.

Jackson, Helen Hunt. *Ramona.* New York: Avon, 1970. First published 1884 by Little, Brown.

Julian Eltinge Project. "The Julian Eltinge Biography." *The Julian Eltinge Project.* http://www.thejulianeltingeproject.com/bio.html.

Jurmain, Claudia, and William McCawley. *O, My Ancestor: Recognition and Renewal for the Gabrielino-Tongva People of the Los Angeles Area.* Berkeley, CA: Heyday, 2009.

Kramer, Diane, Norman Mennes and Richard Stanley, eds. *75ᵗʰ Anniversary: Los Feliz Improvement Association, 1916–1991.* Los Feliz, CA: Los Feliz Improvement Association, 1991.

• Lincoln Heights Foundation Los Angeles. "Selig Zoo and Movie Studio." *Lincoln Heights Foundation Los Angeles.* http://www.lincolnheightsla.com/selig.

Los Angeles Conservancy. "Explore L.A. Modern Architecture in America." *Los Angeles Conservancy.* www.laconservancy.org/locations/william-mead-homes.

Los Angeles Department of Water and Power. "The City Owns Its Water." *Los Angeles Department of Water and Power.* http://wsoweb.ladwp.com/Aqueduct/historyoflaa/cityownswater.htm.

McCawley, William. *The First Angelinos: The Gabrielino Indians of Los Angeles.* Banning, CA: Malki Museum Press, 1996.

McWilliams, Carey. *Southern California: An Island on the Land.* 1946. Reprint, Salt Lake City, UT: Peregrine Smith, 1973.

Meares, Hadley. "The Garbutt House in Silver Lake: The Concrete Mansion that Capitalism Built." *KCET Newsletter*, December 20, 2013.

Menefee, David W. *The First Male Stars: Men of the Silent Era.* Albany, GA: Bear Manor Media, 2007.

Mix, Paul E. *The Life and Legend of Tom Mix*. New York: A.S. Barnes and Company, 1972.

Moreno, Antonio. "The True Story of My Life." *Movie Weekly*, November 8–December 13, 1924.

Mulholland, Catherine. *William Mulholland and the Rise of Los Angeles*. Berkeley: University of California Press, 2000.

Myrna Oliver. "George C. Page obituary." *Los Angeles Times*, November 30, 2000. http://articles.latimes.com/2000/nov/30/local/me-59294.

National Film Registry. "National Film Registry Titles 1989–2013." *Library of Congress*. http://www.locgov/film/registry_titles.php.

Newmark, Harris. *Sixty Years in Southern California, 1853–1913*. New York: Knickerbocker Press, 1926.

Nichols, Pete. "Home Video: Arbuckle Shorts, Fresh and Frisky." *New York Times*, April 13, 2001. http://www.nytimes.com/2001/04/13/movies/home-video-arbuckle-shorts-fresh-and-frisky.html.

Norris, Frank. *The Octopus*. Boston: Houghton-Mifflin, 1958.

Page, George Charles. *The Life Story of George Charles Page: In My Own Words*. Glendale, CA: Griffith Publishing, 1993.

Pitt, Leonard. *The Decline of the Californios: A Social History of the Spanish-Speaking Californians, 1846–1890*. Berkeley: University of California Press, 1971.

Portland Cement Association, Structural Bureau. "August 1950 Concrete Information No. AC 10, Second Edition." *Portland Cement Association*. http://cement.org/decorative/pdfs/AC10.pdf.

Rudd, Hynda. "Jews of the Intermountain West, 1826–1865." Master's thesis. University of Utah, 1978.

Russell, Betty Harper. *Mabel: Hollywood's First I Don't Care Girl*. New York: Ticknor and Fields, 1982.

Ryon, Ruth. "Silver Lake Rustic Redefined: A Multiple-Story Post-and-Beam Alpine Lodge on Pill Hill Undergoes a Sleek Remodeling." *Los Angeles Times*, March 18, 2008. http://articles.latimes.com/2008/mar/16/realestate/re-home16.

Seligman, Donald. *Los Feliz and the Silent Film Era: The Heart of Los Angeles Cinema, 1908 to 1930*. Los Feliz, CA: Los Feliz Improvement Association, 2013.

———. *Los Feliz: An Illustrated History*. Los Feliz, CA: Los Feliz Improvement Association, 2010.

Sennett, Mack. *King of Comedy, as Told to Cameron Shipp*. Garden City, NY: Doubleday, 1954.

"Silver Clippings: The Public Service of Herman Silver in the State of California and City of Los Angeles from 1896 to 1908." Unpublished, n.d.

Silver Lake Reservoirs Conservancy. "Mission Statement." *Silver Lake Reservoirs Conservancy.* www.silverlakereservoirs.org.

Silver Lake website. "About the Silver Lake Community, Los Angeles, California." *Silver Lake Web Site.* http://silverlake.org/about_silverlake/aboutSL_frmset.htm.

Sklar, Robert. *Movie-Made America: A Cultural History of the United States.* New York: Vintage, 1994.

Sponholtz, Shirley. "A Brief History of Road Building." *Triple Nine Society.* www.triplenine.org/articles/roadbuilding.asp.

Sutton, Matthew Avery. *Aimee Semple McPherson and the Resurrection of Christian America.* Cambridge, MA: Harvard University Press, 2007.

United States Census Bureau. http://www.census.gov.

Walker, Brent E. *Mack Sennett's Fun Factory: A History and Filmography of His Studio and His Keystone and Mack Sennett Comedies.* Jefferson, NC: McFarland, 2010.

Walker, Jim. *Images of Rail: Pacific Electric Red Cars.* Charleston, SC: Arcadia, 2006.

Wannamaker, Mark, and Robert W. Nudelman. *Images of America: Early Hollywood.* Charleston, SC: Arcadia, 2007.

Watson, Coy. *The Keystone Kid: Tales of Early Hollywood.* Santa Monica, CA: Santa Monica Press, 2001.

———. *Watson and Wimer Background and Courtship.* N.p.: Unpublished.

Watson, Delmar. *Quick Watson, the Camera: Seventy-Five Years of News Photography.* Hollywood, CA: Delmar Watson, 1975.

Woolsey, Ronald C. *Migrants West: Toward the American Frontier.* Sebastopol, CA: Grizzly Bear Publishing, 1996.

Young, Betty Lou. *Our First Century: The Los Angeles Athletic Club, 1880–1980.* Los Angeles: LAAC Press, 1979.

Zimmerman, Tom. *Paradise Promoted: The Booster Campaign that Created Los Angeles, 1870–1930.* Los Angeles: Angel City Press, 2008.

INDEX

ABOUT THE AUTHORS

Michael Locke is a longtime resident of Southern California. He served on the first Silver Lake Neighborhood Council, as the Region One representative and vice chair, and was founder of the Beautification Committee. Since 2003, he has edited and published the *Silver Lake News*, an online community newspaper. He is also a regular contributing writer and photographer for the *Los Feliz Ledger*, the *Los Feliz Observer* and the *Los Angeles City Historical Society Newsletter*. He lives in the Durex Model Home (Los Angeles Historic-Cultural Monument Number 1025) in Los Feliz with his wife, Donna Jean.

Vincent Brook has a PhD in film and television from UCLA. He teaches media studies at the University of California, Los Angeles; the University of Southern California;

Michael and Donna Locke with Maggie in Griffith Park, April 28, 2012. *Courtesy of Michael Locke.*

Vincent and Karen Brook, 2013. *Photo by Michael Locke.*

California State University, Los Angeles; and Pierce College. He has authored or edited five other books, most recently: *Land of Smoke and Mirrors: A Cultural History of Los Angeles* and *Woody on Rye: Jewishness in the Films and Plays of Woody Allen* (both 2013). Born in Van Nuys, he has lived in Silver Lake with his wife, Karen, since 1978.

CPSIA information can be obtained
at www.ICGtesting.com
Printed in the USA
LVOW13*2013090418
572795LV00013B/143/P